DWAYNE JOHNSON
THE ROCK

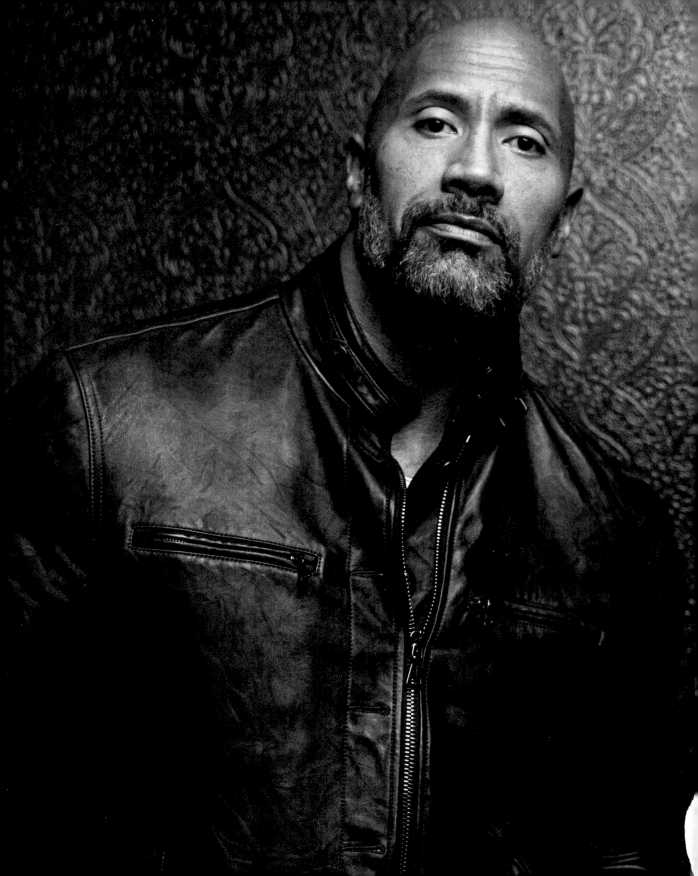

DWAYNE JOHNSON
THE ROCK

His Life, His Movies,
His World

PHOTOGRAPHS BY

First published in the United States by St. Martin's Press,
an imprint of St. Martin's Publishing Group

THE ROCK. Copyright © 2020 by Hiram Garcia. All rights reserved.
Printed in the United States of America. For information,
address St. Martin's Publishing Group,
120 Broadway, New York, NY 10271.

www.stmartins.com

The Library of Congress Cataloging-in-Publication Data is available upon request.

ISBN 978-1-250-22042-4 (hardcover)
ISBN 978-1-250-22043-1 (ebook)

Book design by Michelle McMillian

Our books may be purchased in bulk for promotional, educational,
or business use. Please contact your local bookseller or the
Macmillan Corporate and Premium Sales Department at
1-800-221-7945, extension 5442, or by email at
MacmillanSpecialMarkets@macmillan.com.

First Edition: 2020

10 9 8 7 6 5 4 3 2 1

To my late grandparents John and Chela Quintana.

They always believed in me and I hope I've made them proud.

Introduction

This is a record, in photographs, of a brotherhood and a friendship that isn't quite lifelong yet, but that I know will be. Let's call it a story that's only been told halfway. I met Dwayne Johnson—DJ to most friends and family—back in 1991. I was visiting my sister Dany at the University of Miami and she was excited to introduce me to her new boyfriend. Now, even though I was only a freshman in high school, I was still usually bigger than anyone my sisters dated. That all changed when I met DJ, who at that time could put up 500 pounds on the bench. We immediately bonded over video games and our brotherhood began. Little did I know to what extent Dany's, DJ's, and my life would end up being intertwined.

Today, almost thirty years after DJ and I met, we three have come together in many creative ways but none more special than Seven Bucks Productions. We've jointly produced everything from *Jumanji: The Next Level* and *Hobbs &*

Shaw to NBC's *The Titan Games* and HBO's *Ballers*. Then there are our other ventures like Teremana Tequila and our health, wellness, and entertainment expo Athleticon. Needless to say, we like to work hard and have a passion for creating entertainment in lots of different ways.

When I decided to put together a collection of photos of DJ's and my memories together, I realized they told a story others might enjoy, too. In *The Rock*, you'll get to see DJ through my eyes: the highs and joys of life; the tougher times that we all go through as individuals; DJ out in the world with fans and friends; and, more intimately, relaxing and enjoying family time with his wife Lauren Hashian and his three daughters Simone, Jasmine, and Tiana. I hope you like looking at these pictures as much as I liked taking them. DJ is the ultimate entertainer and the biggest movie star in the world. But I hope you understand from these photos that he's just one of us and—most important—a really good guy!

PART ONE

In His Life

For years, DJ's former Hollywood reps had advised him that once he'd achieved stardom in the movies, he could never go back and wrestle again. But DJ didn't want wrestling to stay in his past. Not only was wrestling a family business and the platform that allowed him to make the leap to Hollywood, it was also his connection to the fans who meant everything to him. DJ decided to make a change and find new reps who supported his dreams and his desire to return to the ring. He came back in a record-breaking way and became a world champion again. The first thing he did after winning the belt in Miami was get out of the ring to give his first-born daughter Simone a kiss.

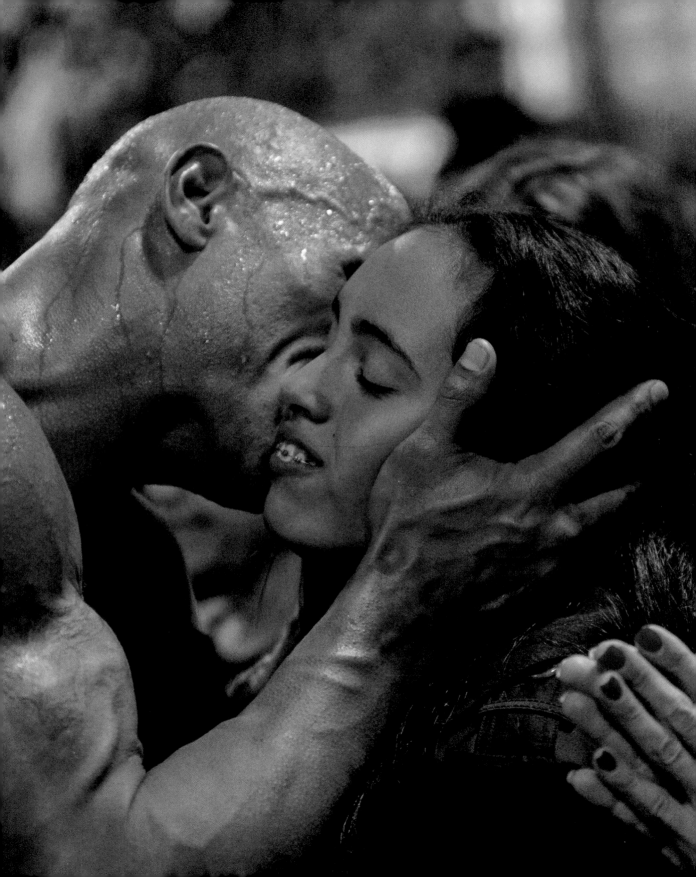

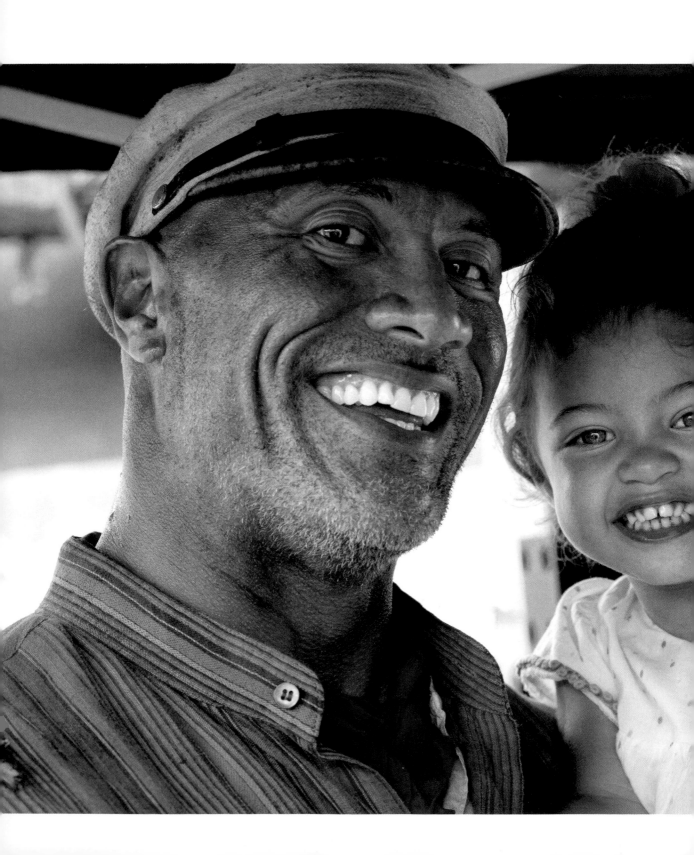

DJ is a machine in all he does, with an unmatched work ethic. As the scale and number of our projects grew, though, it was starting to take a toll on him, and he realized that he needs his family with him whenever he works on location. Nothing makes him light up more than when they visit. This sweet snap is from his daughter Jasmine's first visit to the *Jungle Cruise* set in Kauai.

Dany and DJ met in the 90s and have always driven each other to greatness. They're each powerhouses in their own right, so it's easy to understand how the teaming of the two has resulted in creating one of the most powerful entities in global entertainment today. Despite working together, it's a rare treat when we are all in the same room. I was happy to grab this shot of them during a photo shoot in Vancouver.

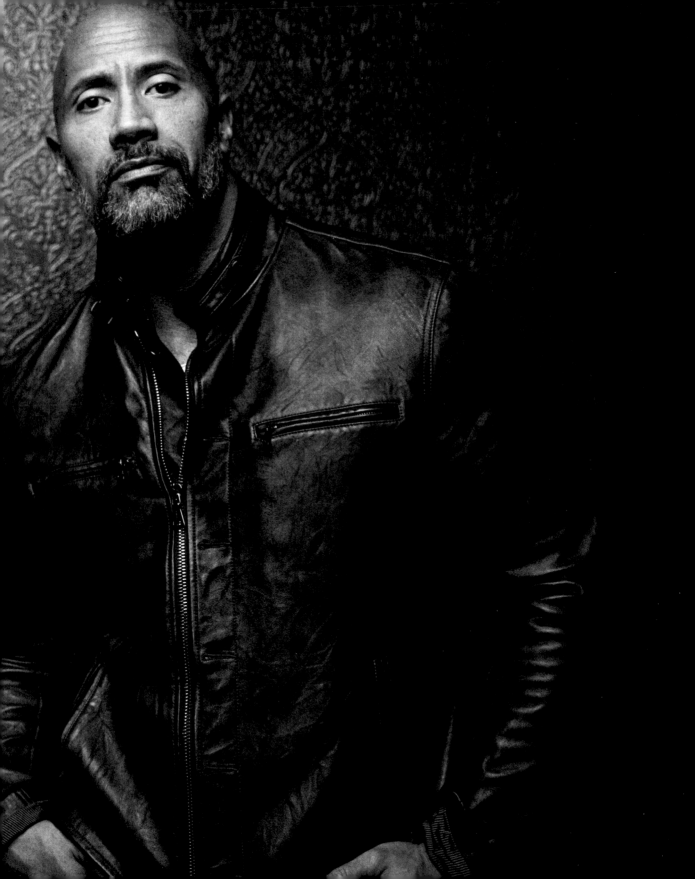

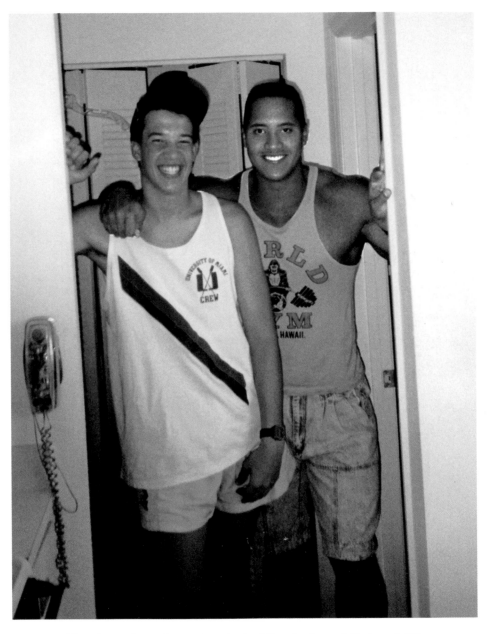

Here's a photo from the trip to Miami where I first met DJ.
We were clearly fashion-forward.

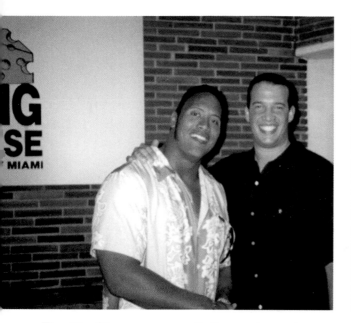

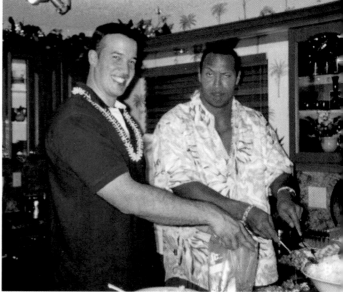

The Big Cheese was an Italian restaurant we visited frequently back in our Miami days. Nothing made us happier than to feast on a giant pizza. (Can't you tell from our grins?)

Both of our families are big on traditions from our heritage. Here we're wearing leis for a family party while helping in the kitchen—which is a much rarer tradition!

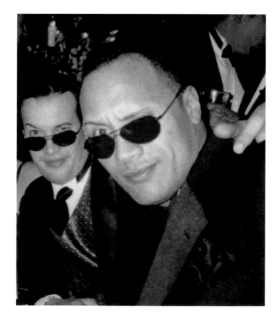

Growing up, my sister Dany and I would often pop our eyebrow at each other for a laugh. Little did we know that DJ would make that eyebrow pop so iconic. Here we both are popping the brow—it's clear why DJ's is the famous one!

No matter where we are,
the work can never stop—much like
DJ's training. This photo is from an
Under Armour shoot we did in
Hawaii on down days while on
location filming *Jumanji*:
Welcome to the Jungle.

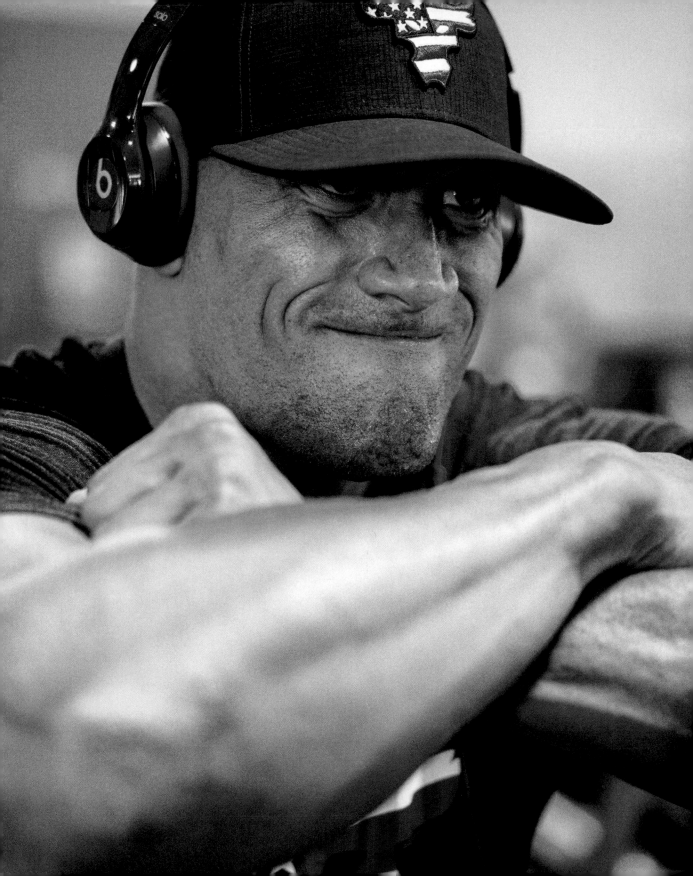

I wasn't planning to shoot anything on the day I joined DJ, Lauren, and Jasmine at the Georgia Aquarium in Atlanta, but when I saw them in front of this tank that dwarfs even The Rock, I was glad I had my Leica with me.

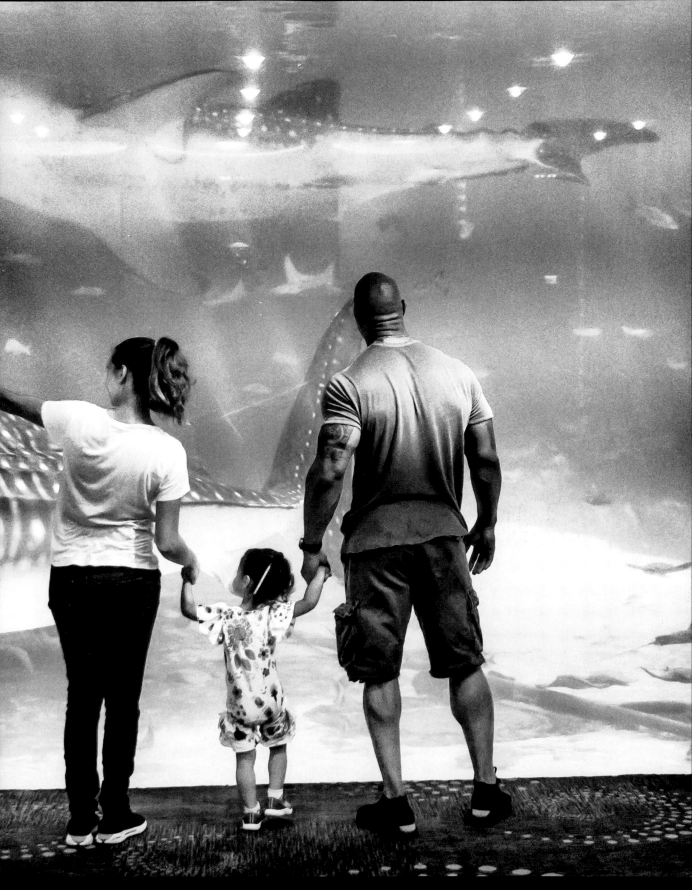

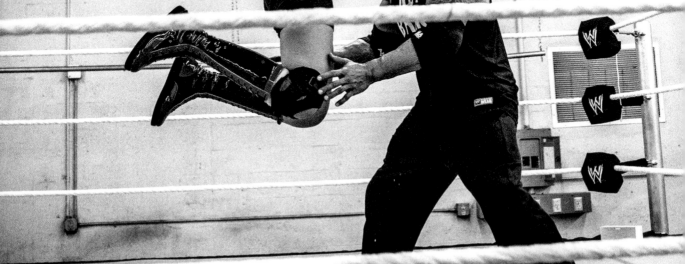

Simone has always been interested in wrestling. This is a glimpse of an early father-daughter training session—DJ teaching Simone how to deliver a head butt with flair!

Action scenes on and underwater are often filmed in tanks. Before an actor can do tank work, they are usually required to get SCUBA certification. Here's DJ taking SCUBA lessons before he started filming *Journey 2: The Mysterious Island*.

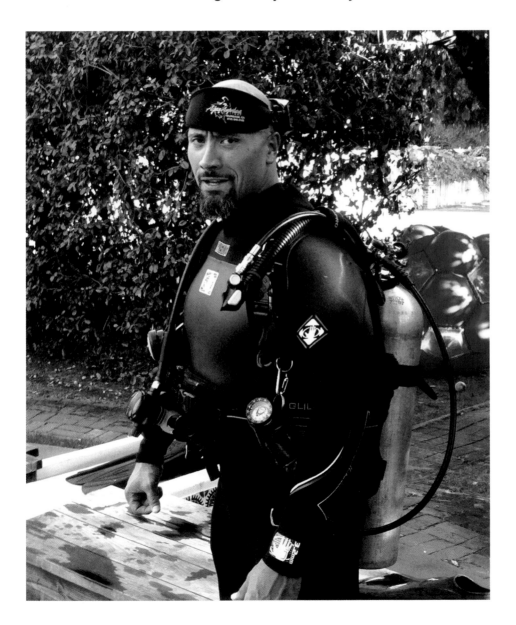

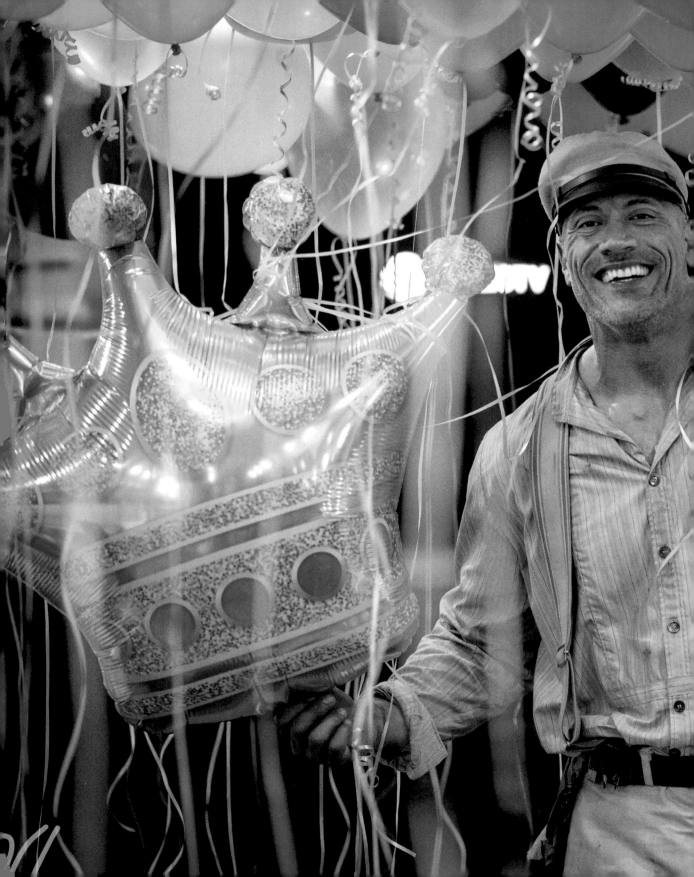

Making a movie is a blast, but it also takes a very long time. Because of that, our amazing teams often become extensions of our family. Here the *Jungle Cruise* cast and crew, along with Disney, helped us surprise DJ on his birthday and filled his trailer with some big birthday love!

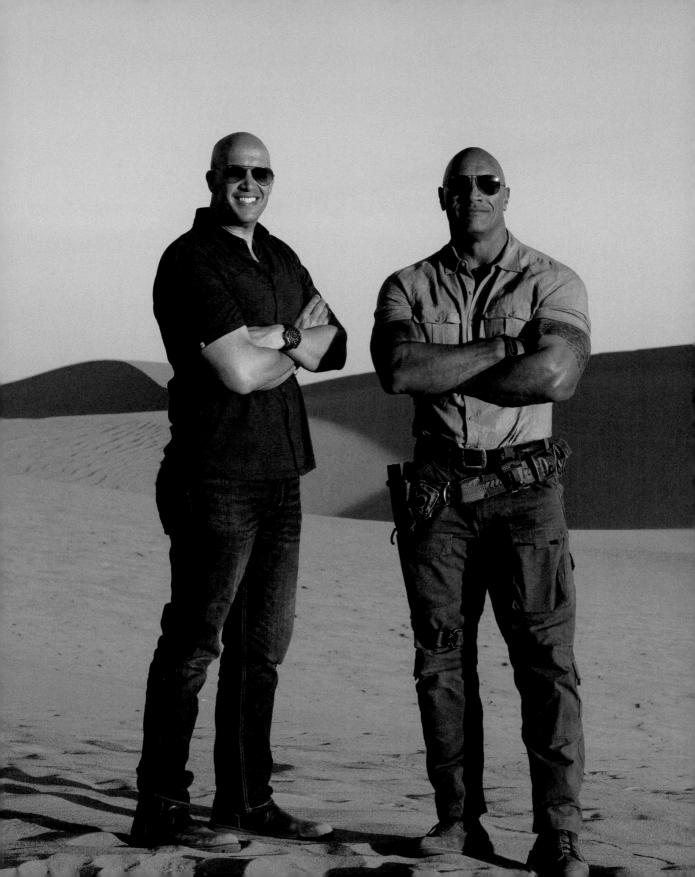

DJ and me in Glamis, California, near the Acolita Dunes Wilderness for *Jumanji: The Next Level*. This image is a significant one, not only because it was the last day of shooting a very special movie, but it was our last day of work on the craziest production run DJ and I had ever experienced. We were coming off of shooting HBO's *Ballers*, Disney's *Jungle Cruise*, NBC's *The Titan Games*, *Hobbs & Shaw*, and *Jumanji: The Next Level*—we were proud of all that we did, but also absolutely exhausted!

(PHOTO BY FRANK MASI)

In January of 2020, we were heartbroken to learn that DJ's father Rocky Johnson had passed away. Losing loved ones is never easy, but the passing of Rocky truly came out of nowhere. On our flight to Florida to celebrate Rocky's life, I was able to capture this moment of DJ working on his father's eulogy, delivered beautifully at a poignant and lovely service. RIP Rocky.

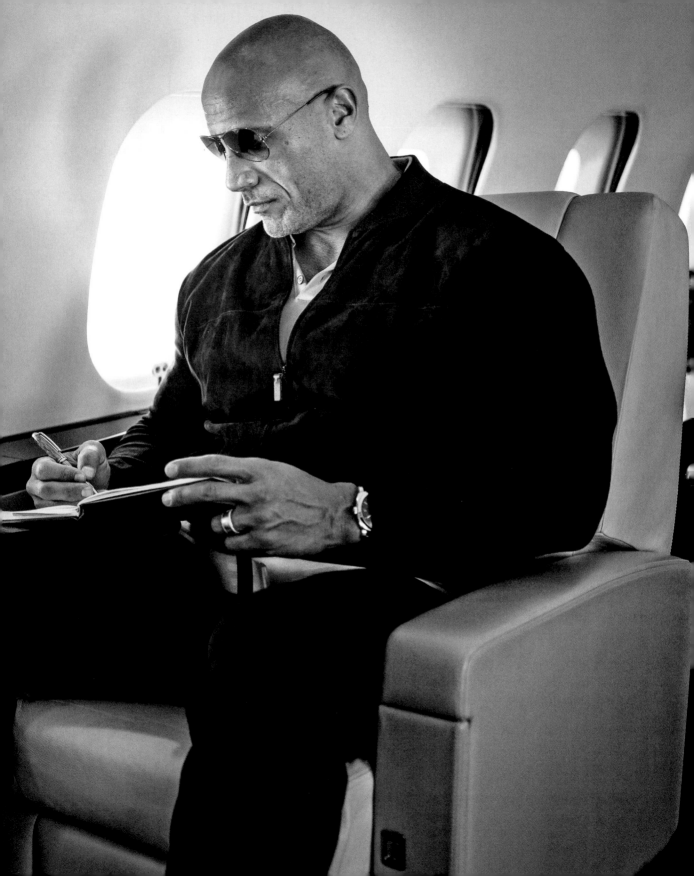

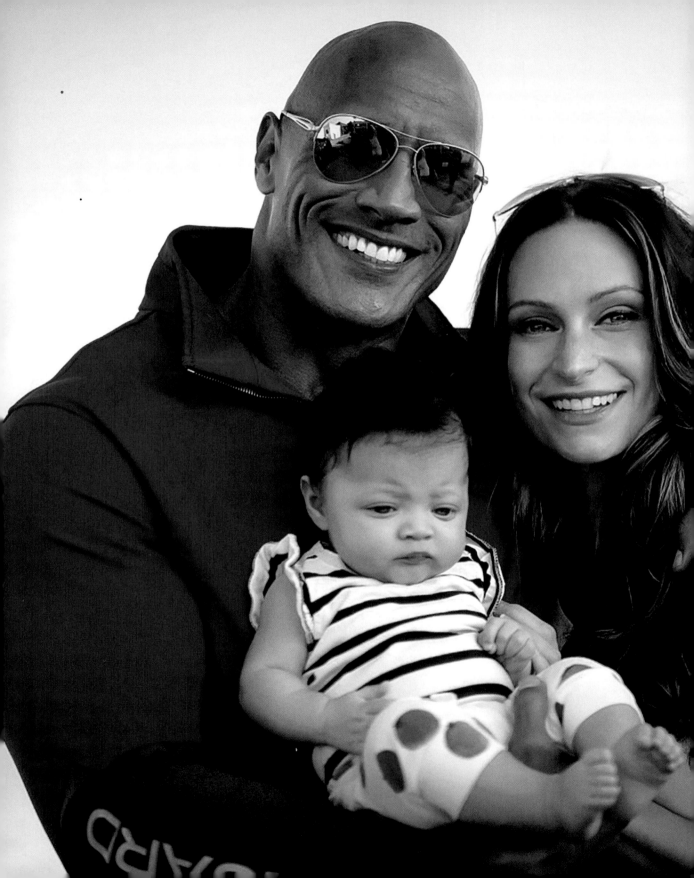

With his beautiful
fiancée (at the time)
Lauren and baby
Jasmine on the
Baywatch set.

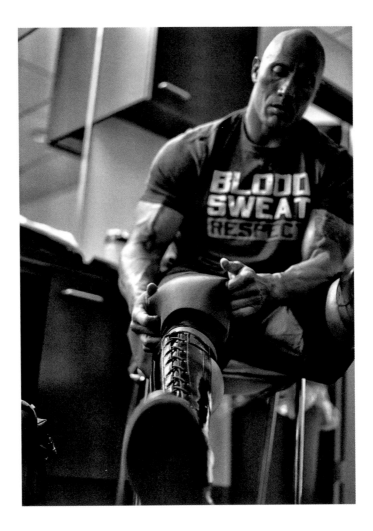

No matter where DJ's career takes him, he will always have professional wrestling in his blood. He absolutely loves the special connection he shares with the fans and often talks about how that connection is like nothing else out there. Here DJ puts on his gear as he prepares to work through a match in the ring before show time.

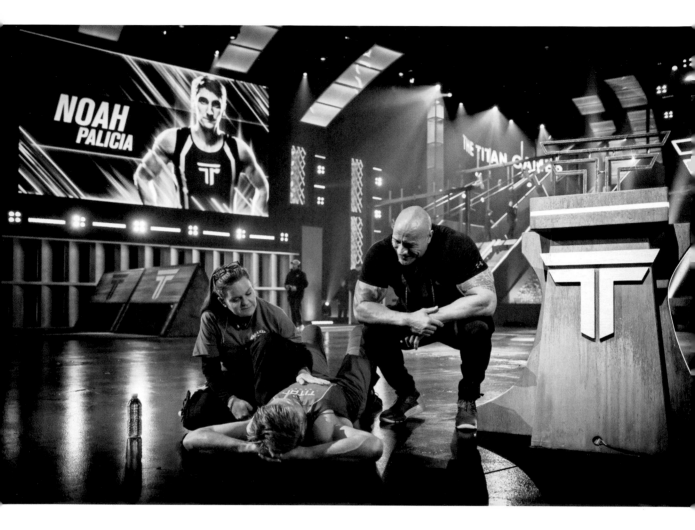

One of the many great things about DJ is the commitment and care he gives to anything he does. DJ worked hard with our team to create *The Titan Games*. Here he checks on a contestant that needed some medical attention after completing the grueling Mt. Olympus course. He was fine—and thrilled he got to share a laugh with DJ as he recovered!

This dromedary looks good enough
to have been created for a movie—
but he wasn't! He's the camel from a
nativity scene at a big holiday party.
DJ couldn't resist taking a selfie.

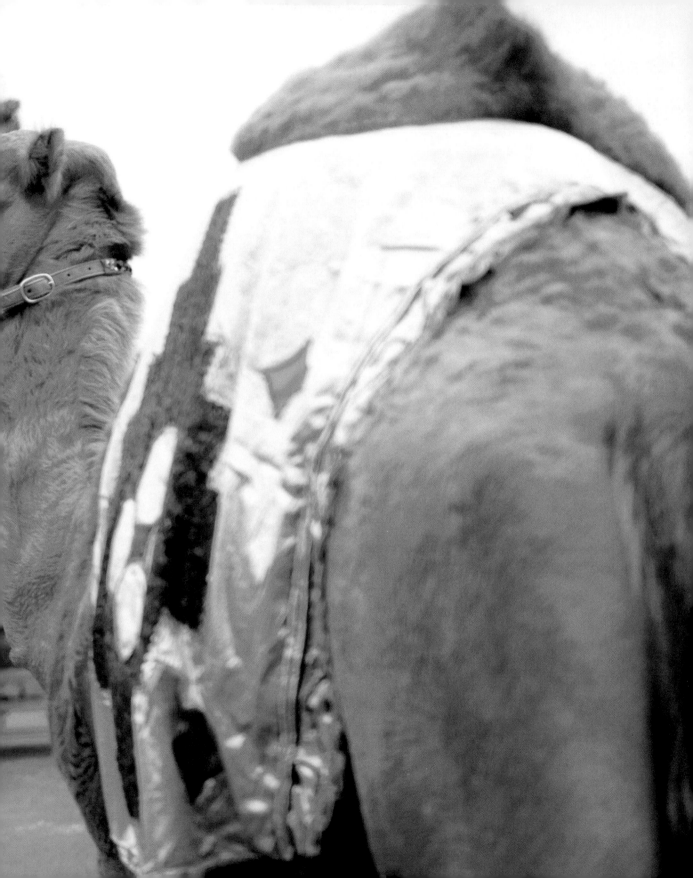

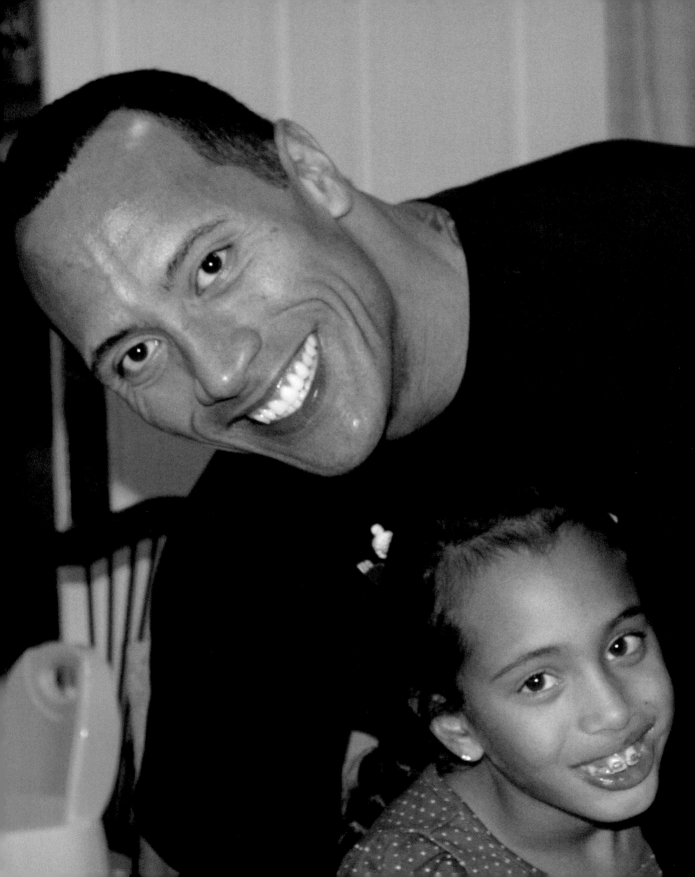

With his daughter
Simone, my niece.

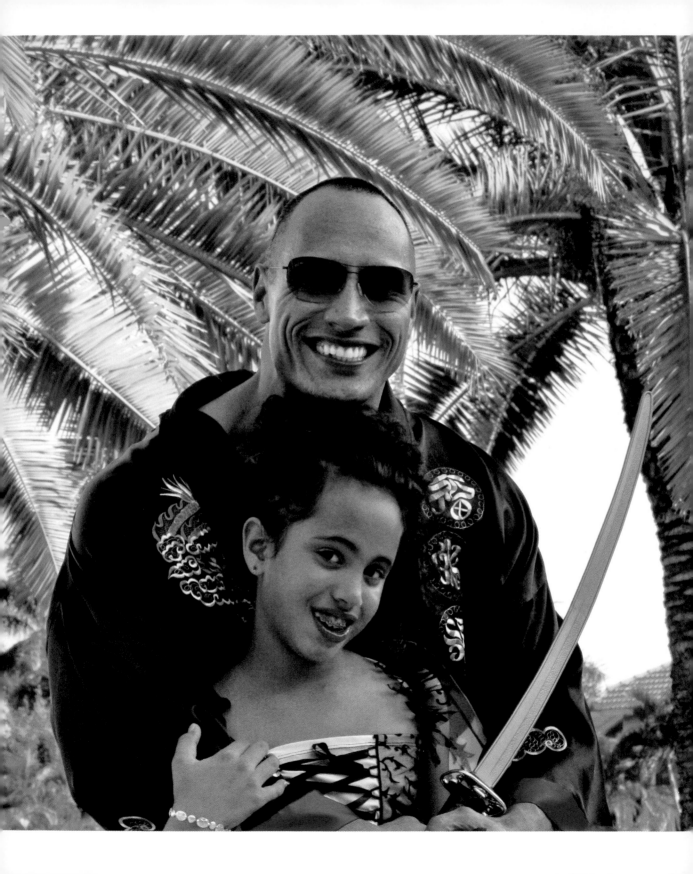

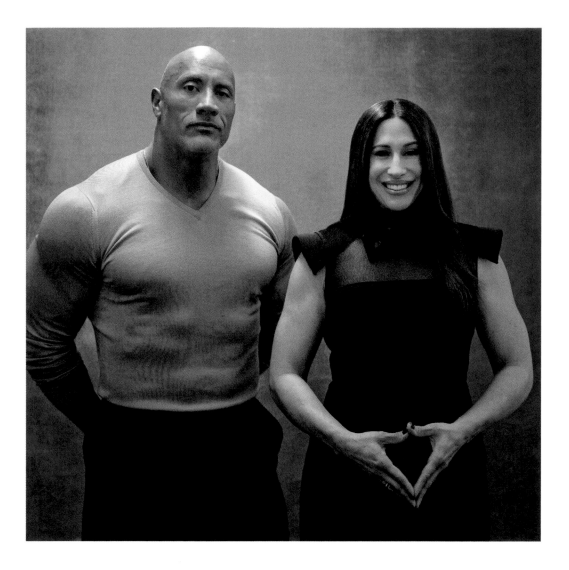

Dany and DJ.

LEFT: Halloween has always been a big holiday for our families and DJ has dressed up in some iconic costumes over the years. Simone picked out what we affectionately called a buff Samurai look. Here the two pose before going trick-or-treating in Florida.

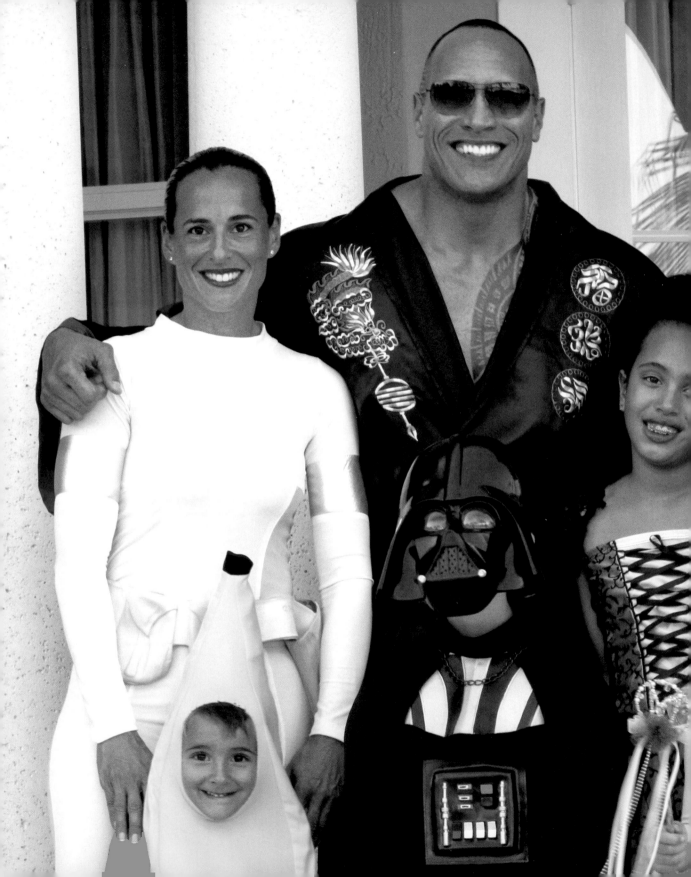

DJ with Dany, Marlo, Simone, Christian, Andrea, and Jordan— his former sister-in-law, nephews, and niece—dressed up for Halloween.

DJ, Dany, and
Simone after one
of Simone's soccer
games. Even at a
young age, Simone
was very athletic,
so it only makes
sense that she is
currently signed
to the WWE's
NXT roster.

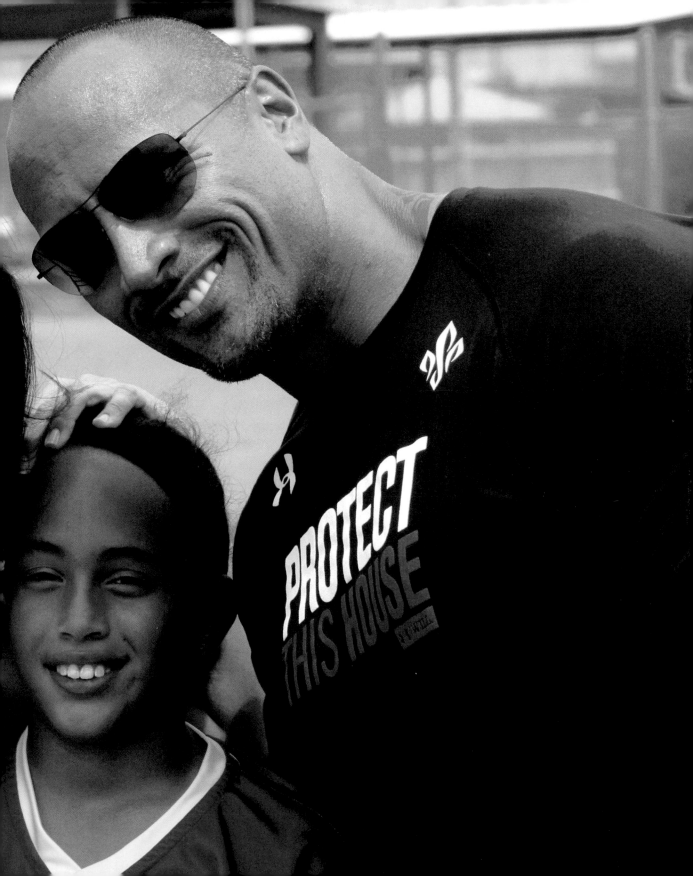

An actor's trailer becomes a sanctuary and home throughout the process of working on a film. For DJ, that means another place he can get to work. Here he's working between takes while filming *Skyscraper* on a table we affectionately called the "GSD" (Get Sh!t Done!) table.

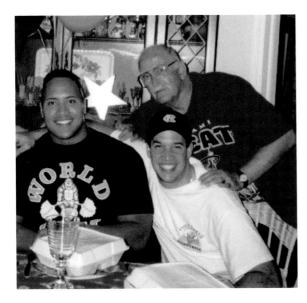

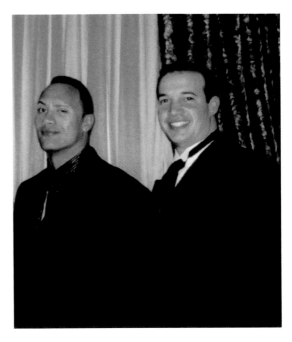

Our families loved to get together and celebrate all occasions. Here is DJ, my late grandfather John, and me celebrating DJ's birthday.

DJ and me at a black tie event at the Biltmore Hotel in Coral Gables, Florida.

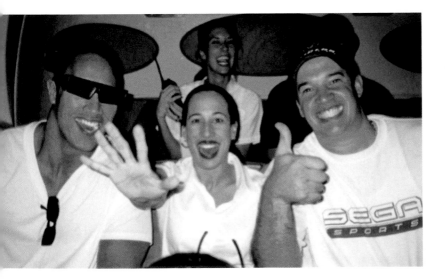

Dany, DJ, and I have always loved theme parks, which is why it was so special for us to be able to make a movie based on Disney's Jungle Cruise ride. This photo is from Universal Studios, right before we went on a ride. DJ stopped the ride to get off right after this photo was taken. (Despite loving theme parks, the big guy gets motion sickness quite easily!)

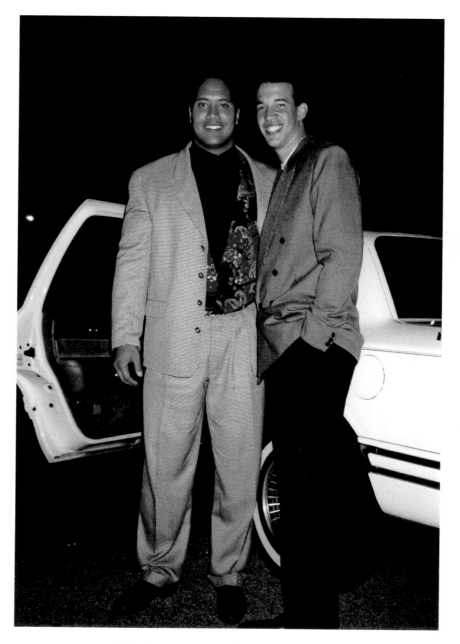

All suited up to go out on the town.

Beasting for the camera with longtime friend
and former WWE and UFC heavyweight
champ Brock Lesnar.

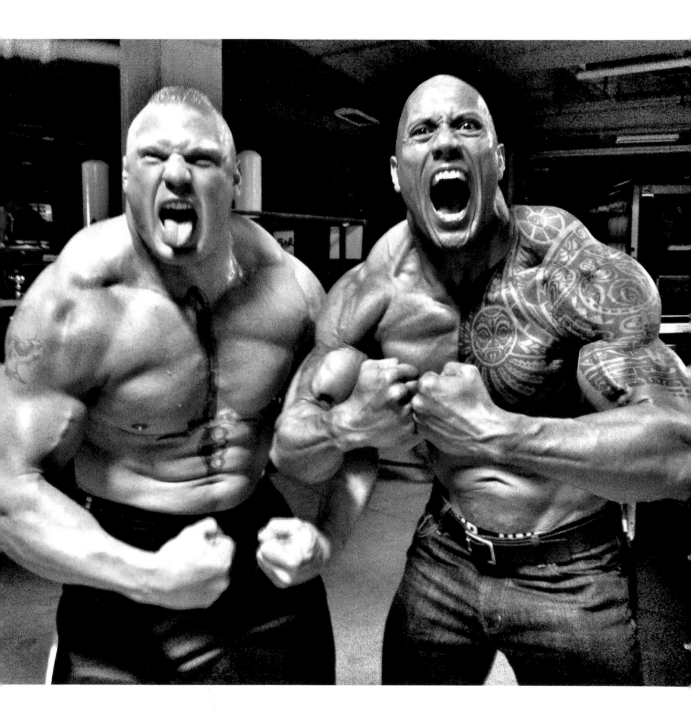

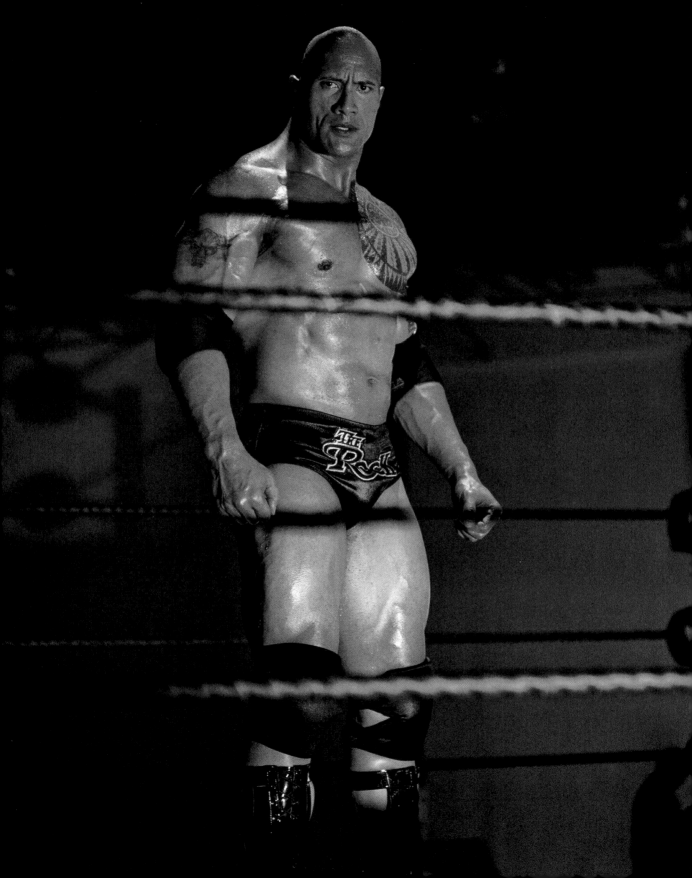

In the ring when The Rock
returned to the WWE in 2011.

Before the birth of the "Iron Paradise," DJ's full traveling gym—composed of more than 40,000 pounds of equipment—the first thing we did when we hit a new city was find a great gym where DJ could train. Here he is at Westbank Athletic Club in Louisiana. Their late mascot Buzz was an unbelievably kind host and always made sure to keep DJ company during meals.

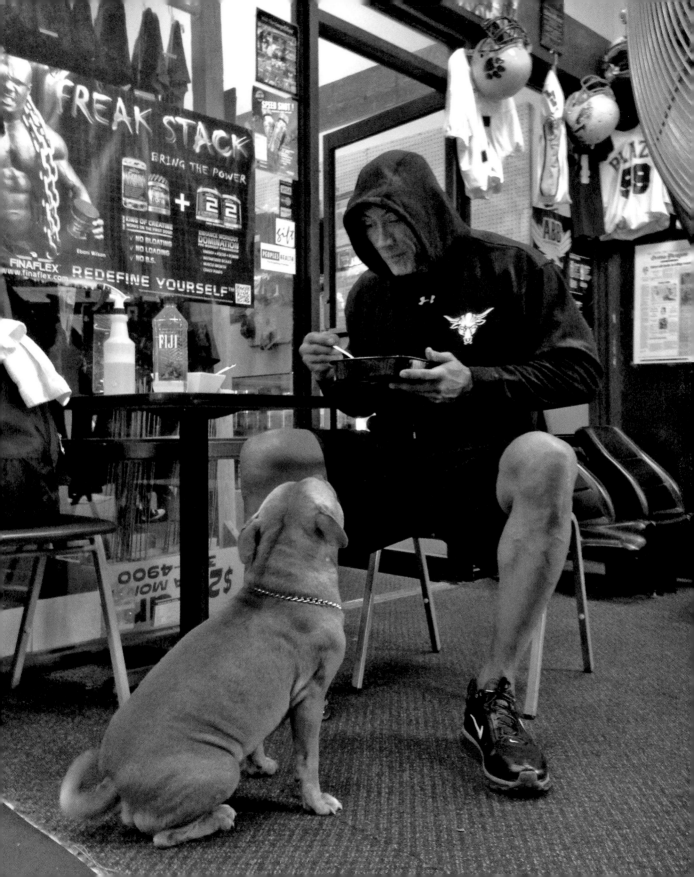

During international tours, we often travel through the night to cover the thousands of miles necessary to get to the next stop. As always, DJ was handling business at all hours during this refueling stop in South Korea.

I remember asking DJ years ago why
he never used a trainer. His answer?
Because no one out there can push
him as hard as he pushes himself.

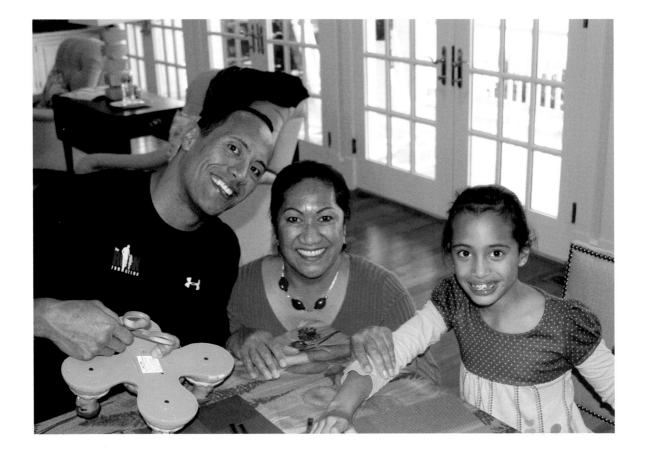

Dwayne, his mother Ata, and Simone at DJ's dinner table at his house in Virginia. This house is in a very quiet part of the state and has always been a favorite destination for the family to get away during down times.

DJ absolutely delights in horsing around with his daughter Simone, on camera and off! At a press tour refueling stop, he couldn't resist a fun photo op.

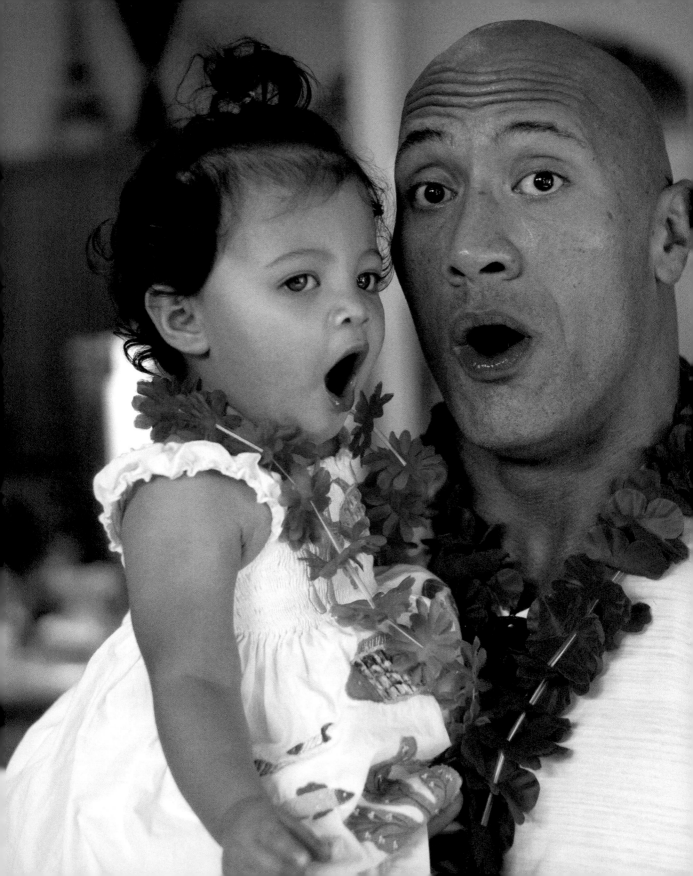

DJ and Jasmine
match each other's
surprised faces on
her birthday.

Any time Lauren and Jasmine are around I can't help but try to grab a picture. The two of them always have the loveliest eyes in any room. Here the family poses for Jasmine's second birthday.

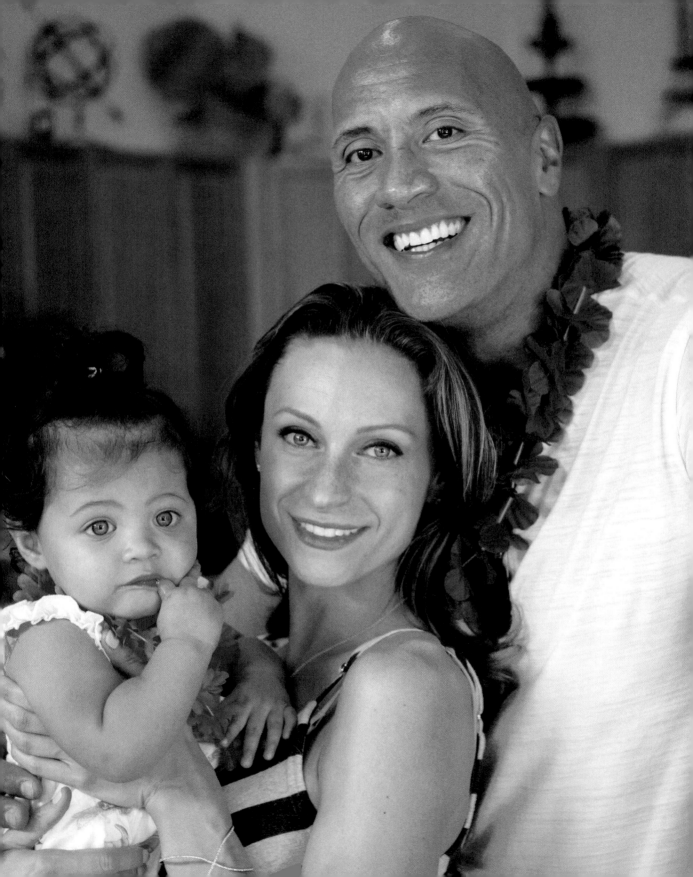

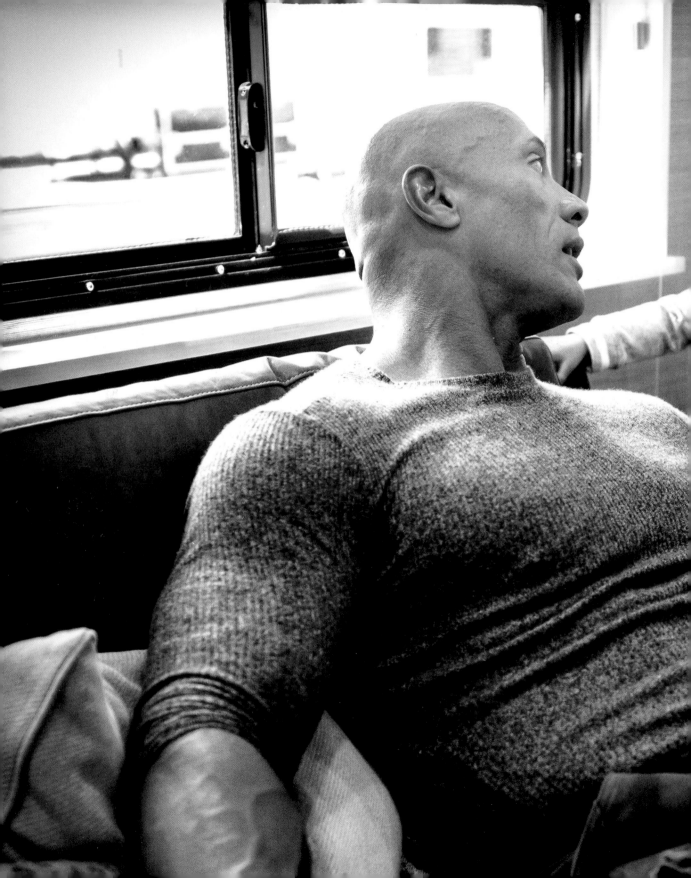

With Jasmine in his trailer during the filming of *Jumanji: The Next Level*.

One of Baby Tia's first trailer
visits during the filming of
Jumanji: The Next Level.

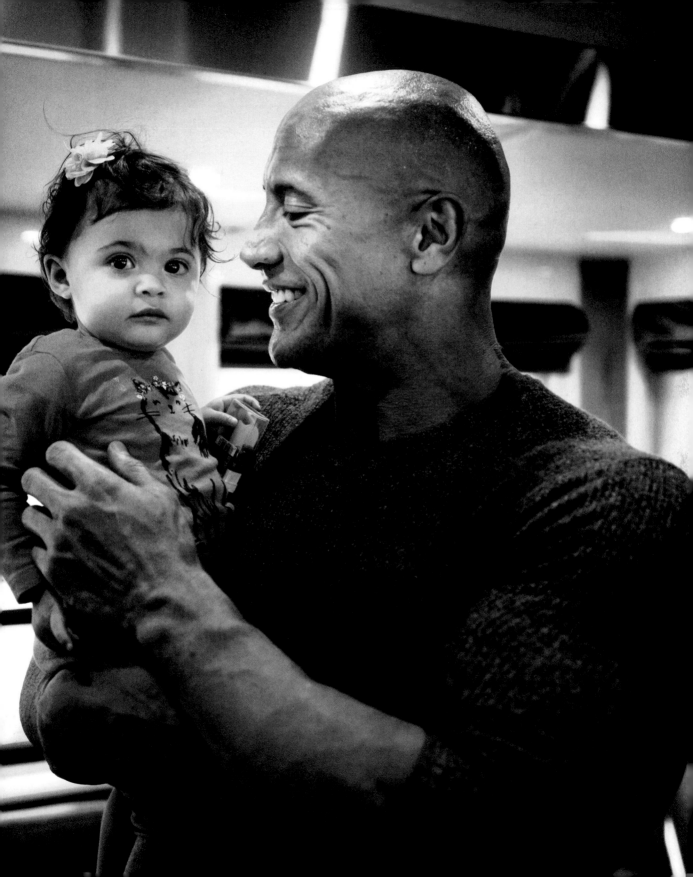

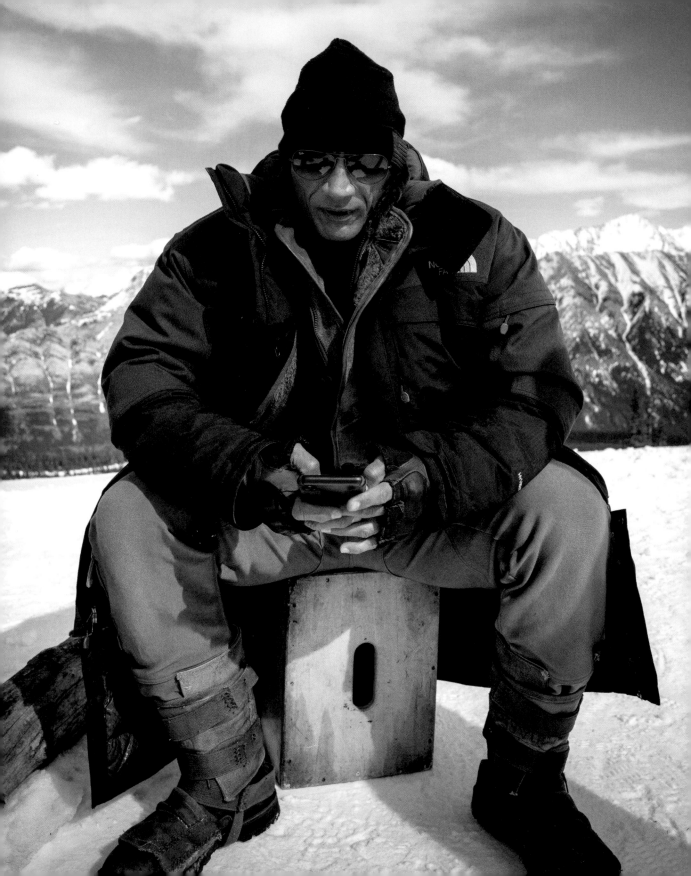

Checking email between takes on a mountaintop in Calgary, Canada.

Waiting for the camera to roll—those momentary downtimes when an actor centers himself before a scene are some of my favorites to capture. This was during additional photography for *Hobbs & Shaw*. This take didn't make the cut: We decided to go without a helmet for the scene.

DJ and Jasmine as a baby,
on the *Baywatch* set.

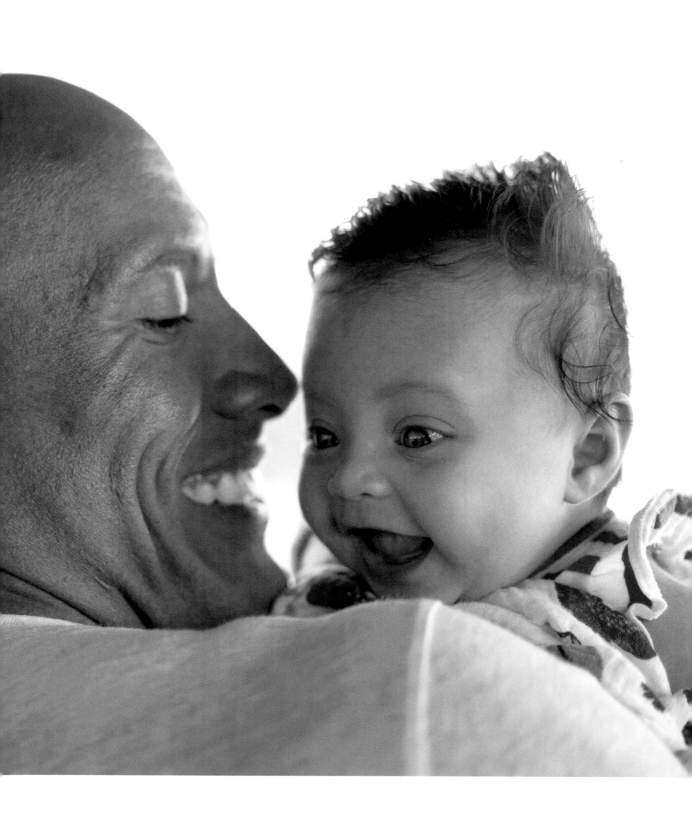

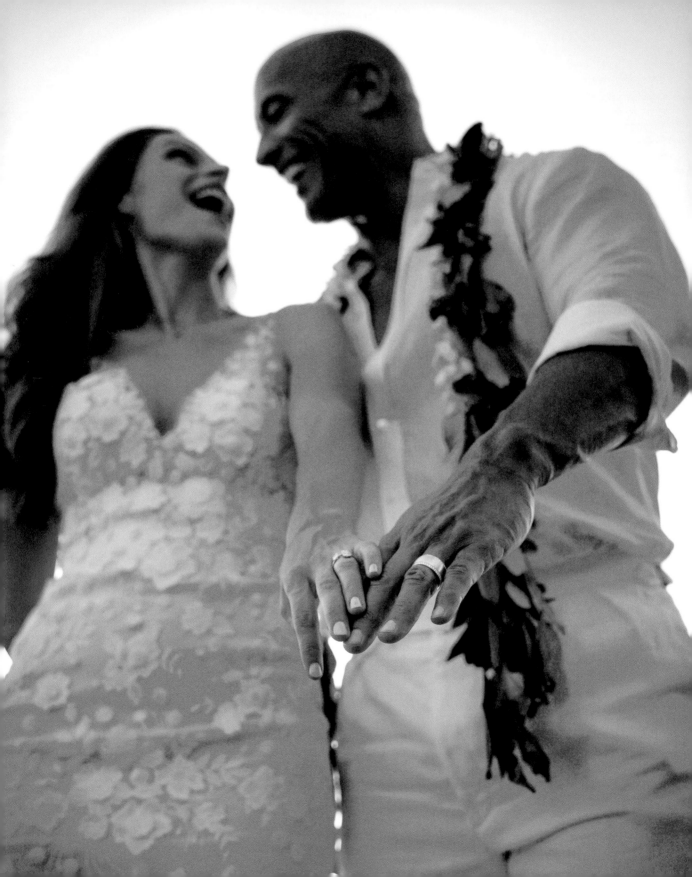

You know true love when you see it, and that has always been apparent when DJ and Lauren are together. The two light each other up in such a special way, as you can see in this snap. DJ and Lauren got married in a private and quaint ceremony in Hawaii. I not only had the honor of attending, but the joy of shooting their wedding.

DJ has always been generous to all, but especially loves to take care of those around him. Here DJ surprises his cousin and longtime stunt double Tanoai with a decked-out custom pick-up truck. Tanoai has been with DJ since his very first film, but they didn't realize they were related until many years later!

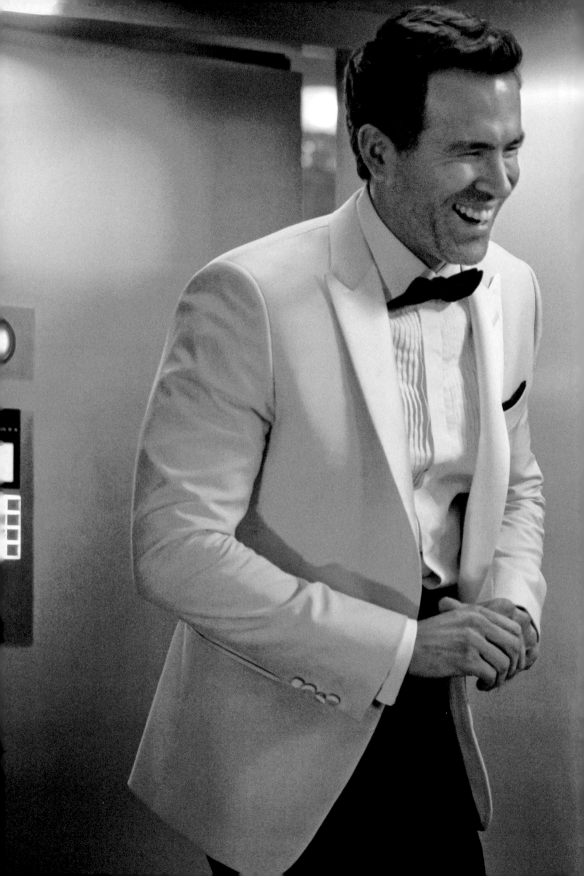

DJ and Ryan Reynolds share a laugh between takes on *Red Notice*. From the moment these two met on *Hobbs & Shaw*, we knew they had special chemistry. We left that project determined to get them back together again, and luckily we did just that with our friends at Netflix.

As a photographer I can't help but be drawn to big beautiful eyes and little Jasmine has some of the most beautiful eyes I've ever seen. I had been trying to catch a good shot of her for a while and finally saw my opportunity right before we took off on a flight.

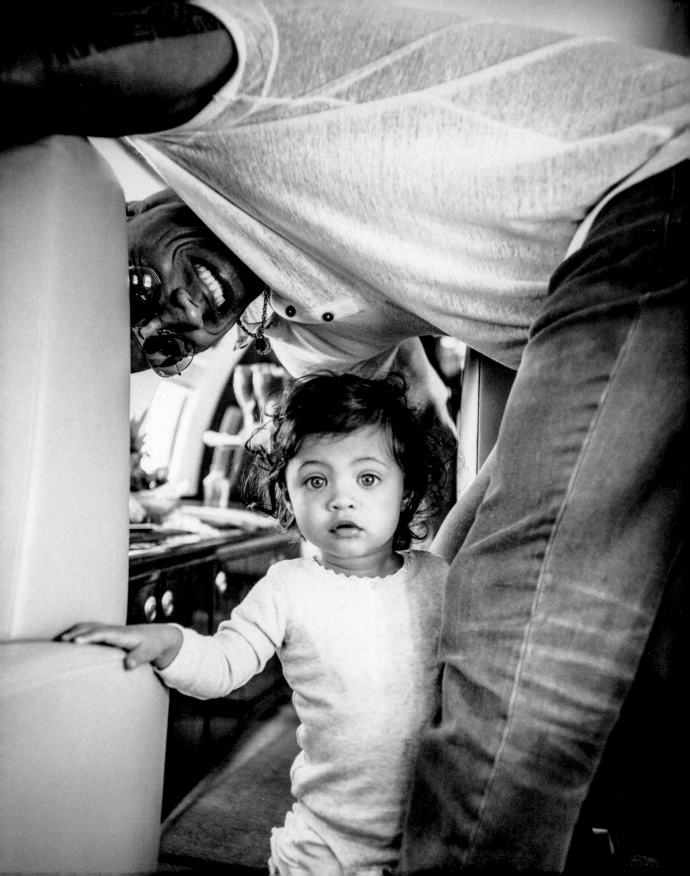

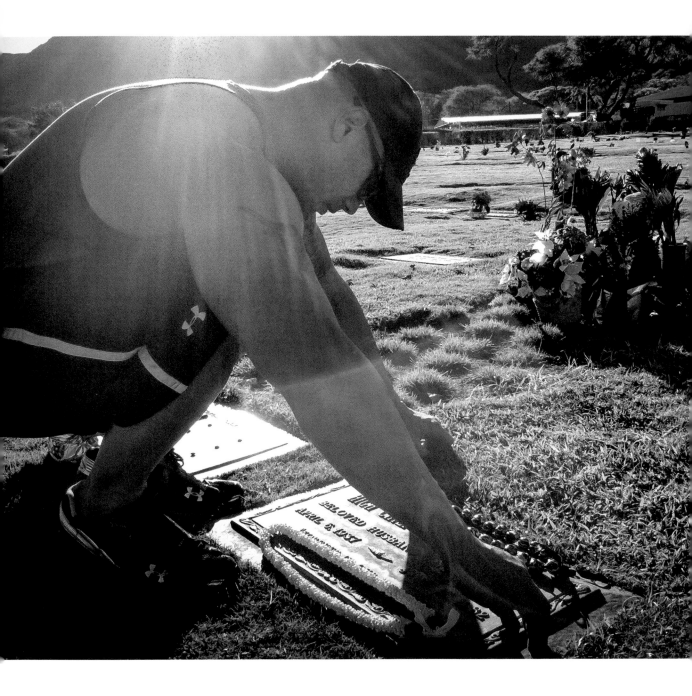

While shooting in Hawaii, DJ brought his grandmother's ashes to place them at the grave of his grandfather, High Chief Peter Maivia. I remember he told them stories about all that had happened in his life, and then said a quiet prayer before picking up his guitar to play a song in their honor. It was a beautiful day and something I will never forget.

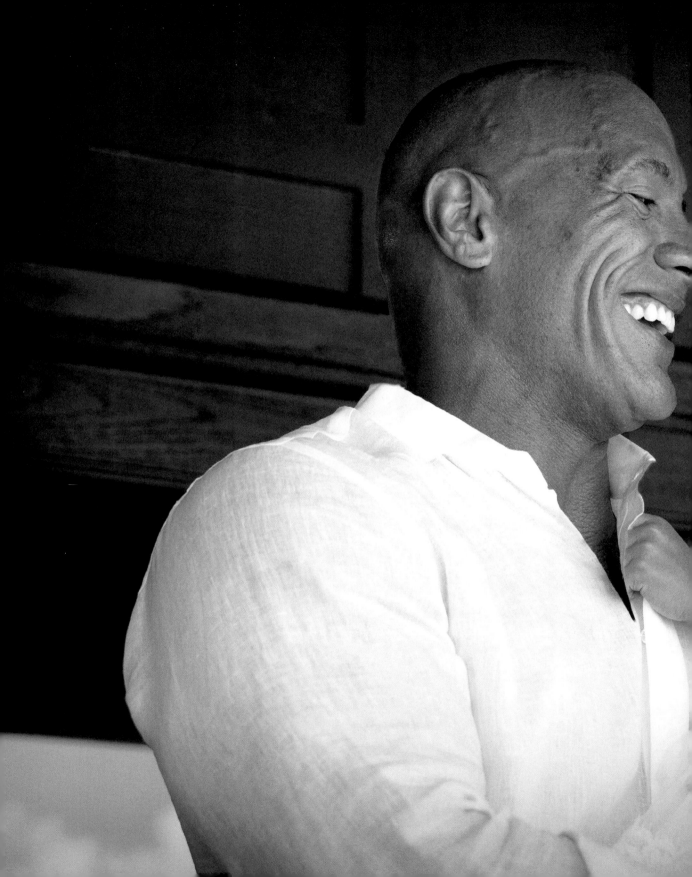

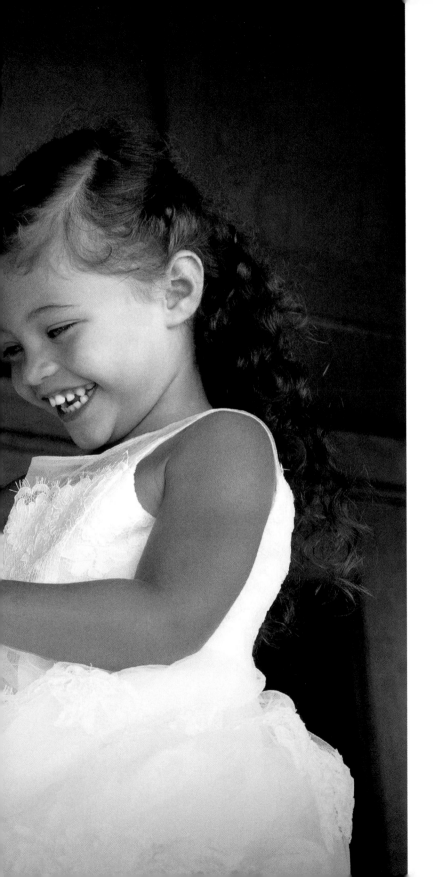

Sharing a laugh
with Jasmine on
his wedding day.

This is one of my favorite shots of DJ
and Lauren from their wedding.

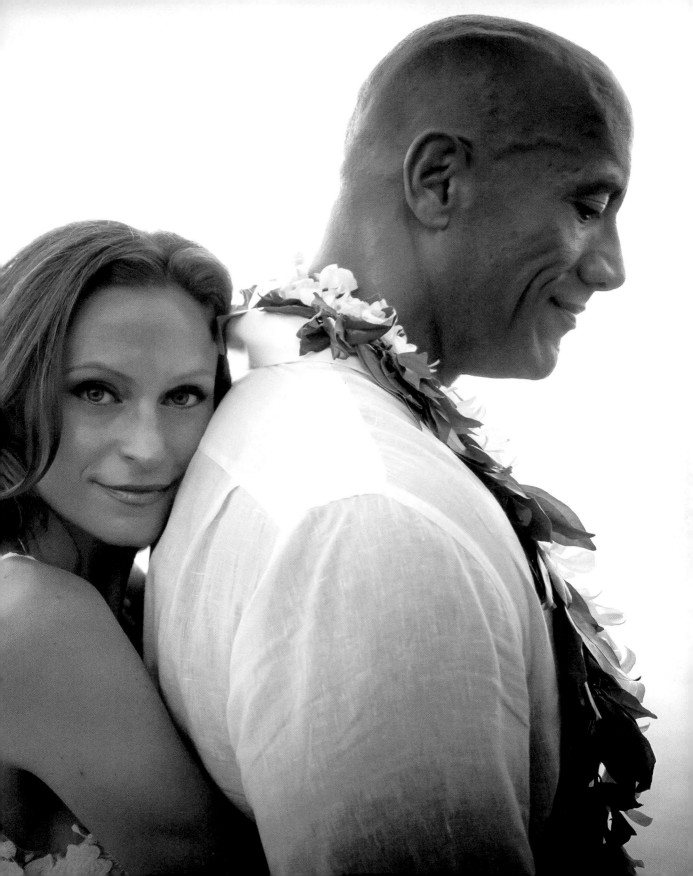

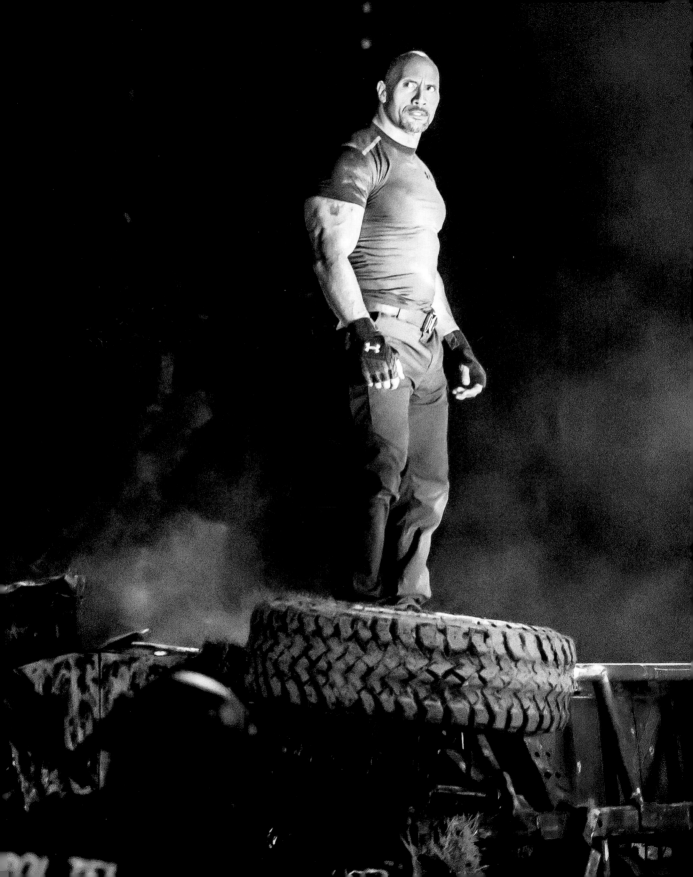

PART TWO

In His Movies

The red-carpet kickoff for
G.I. Joe 2: Retaliation in Taiwan.

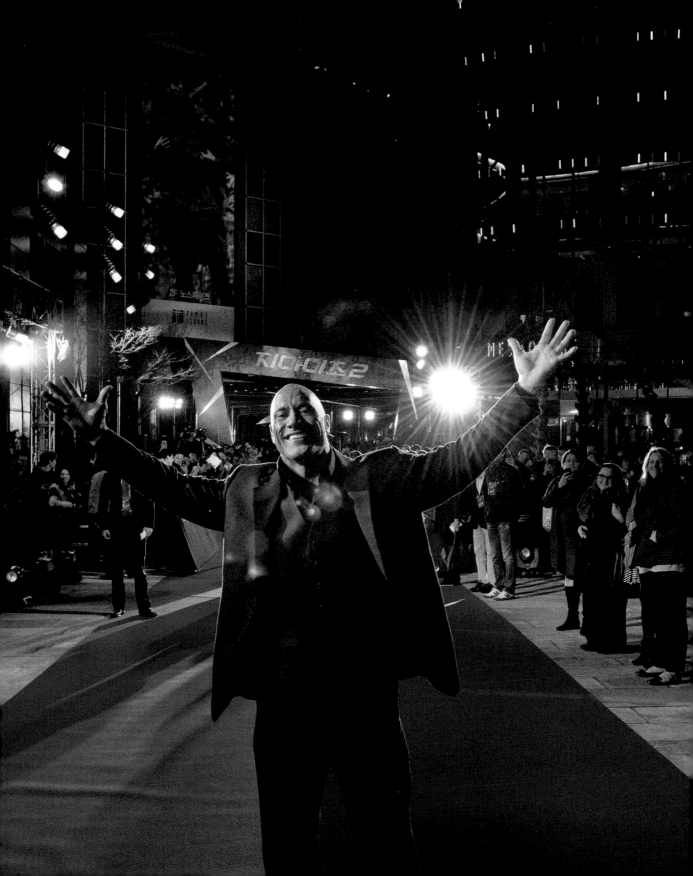

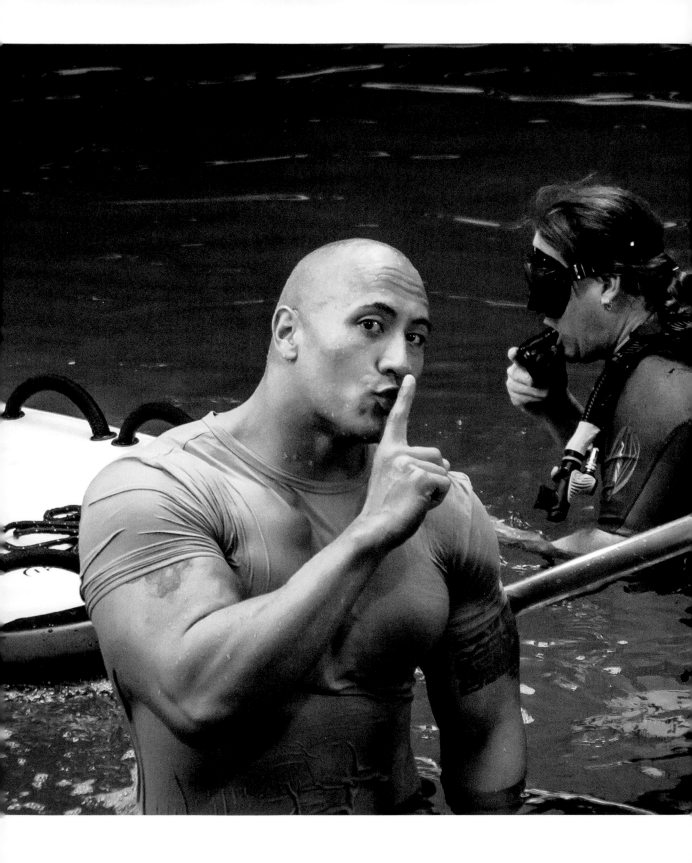

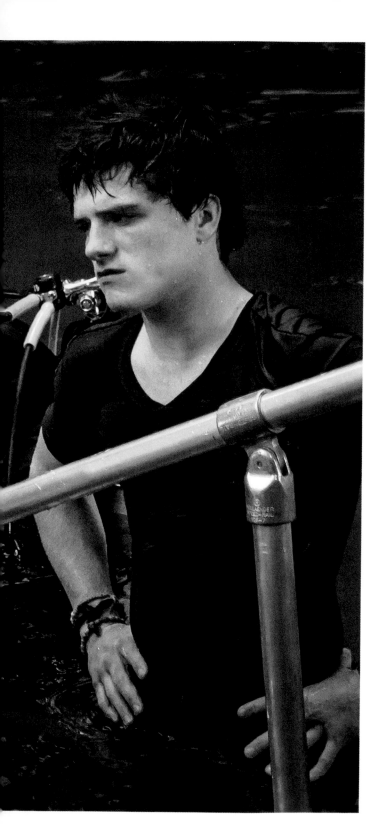

These two always had fun together: DJ and Josh Hutcherson on the set of *Journey 2: The Mysterious Island*. It would be DJ's highest-grossing movie to that point.

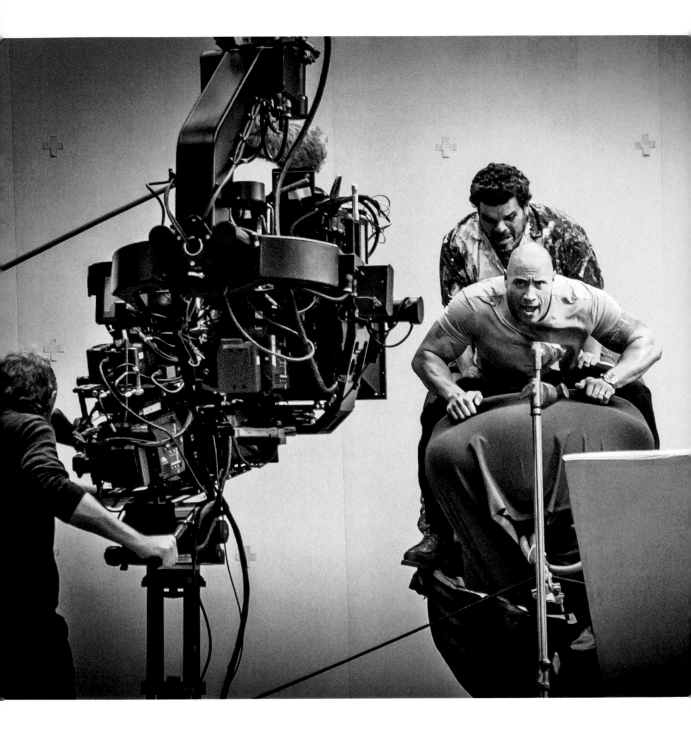

DJ and Louis Guzman ride a rig to create footage that looked like a giant bumble-bee in *Journey 2: The Mysterious Island.*

During a promotional campaign with
Animal Planet for our movie *Rampage*.

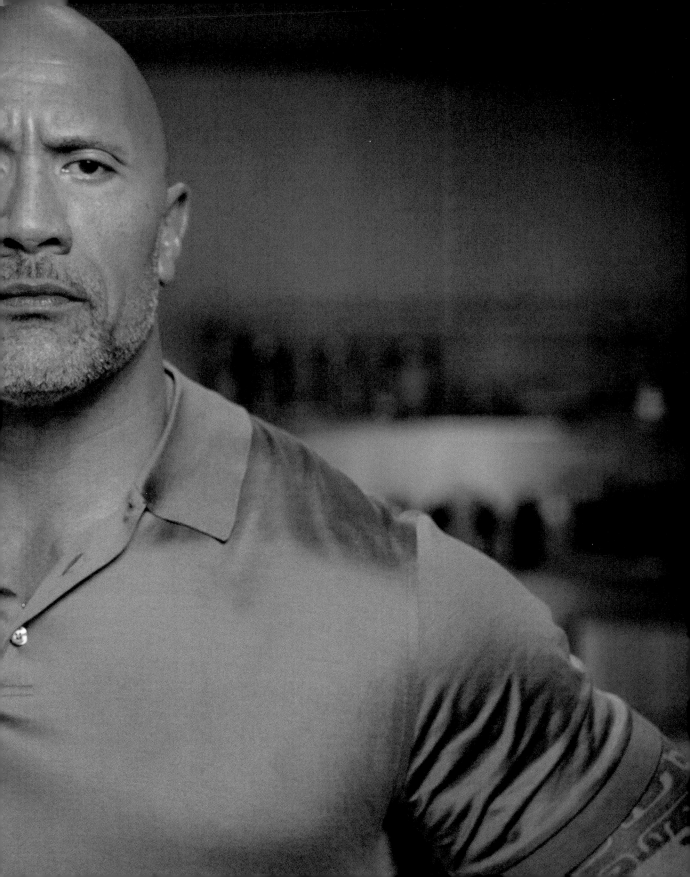

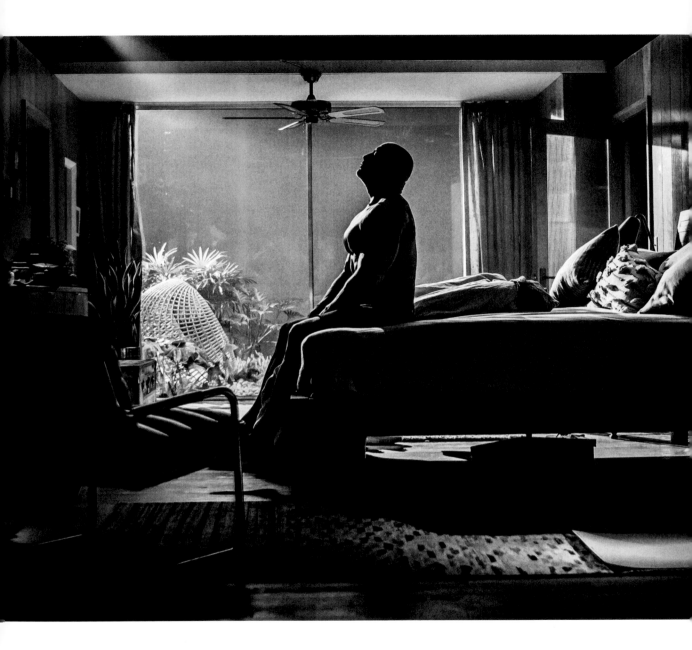

Behind the scenes of DJ's opening sequence as Hobbs
in *Hobbs & Shaw,* shot in London.

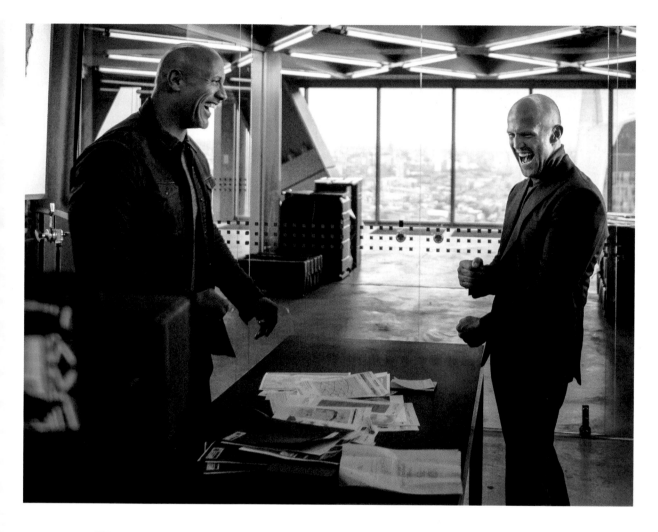

There's nothing like the joy of nailing a perfect take. DJ and Jason Statham had instant chemistry the first time audiences saw them together in the *Fast & Furious* franchise, and fans begged for more, which is why it was such a pleasure to make *Hobbs & Shaw*. In this image, DJ and Jason show that great chemistry while sharing a laugh after a great take on *Hobbs & Shaw*.

The dog in *Hobbs & Shaw* is based on
DJ's real-life family dog Hobbs. On this day
Hobbs was actually supposed to be
in the scene but wasn't feeling well because
of something he ate. We ended up using
another dog to help us out till Hobbs was
ready for his big screen debut the next day.

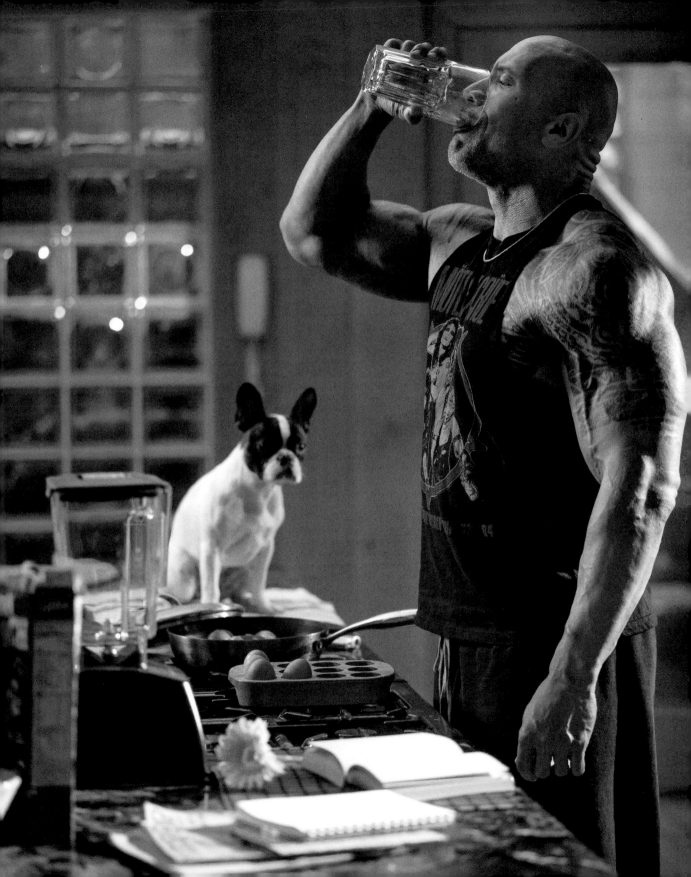

Working out for the *Hobbs & Shaw*
montage sequence.

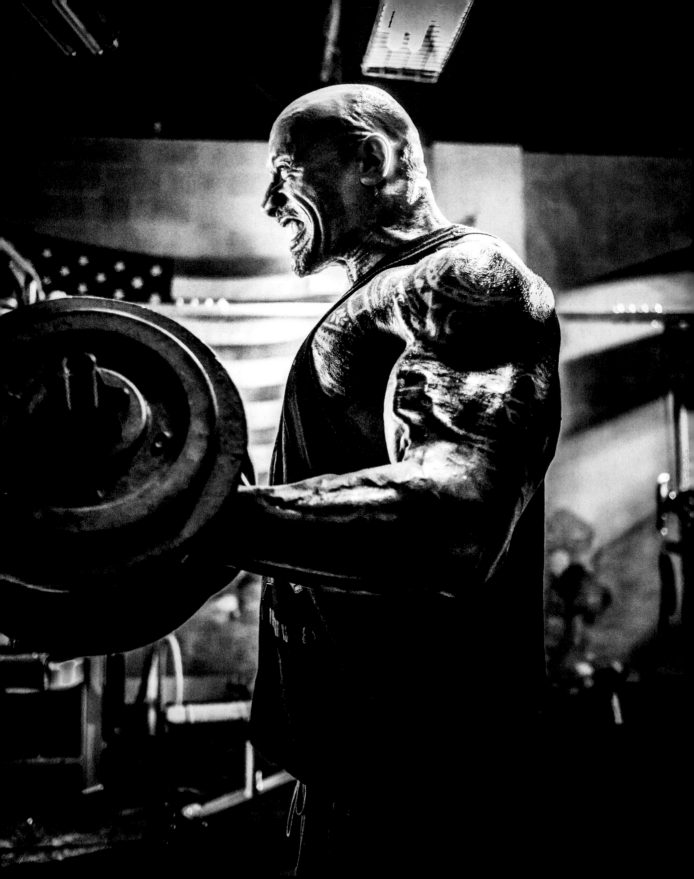

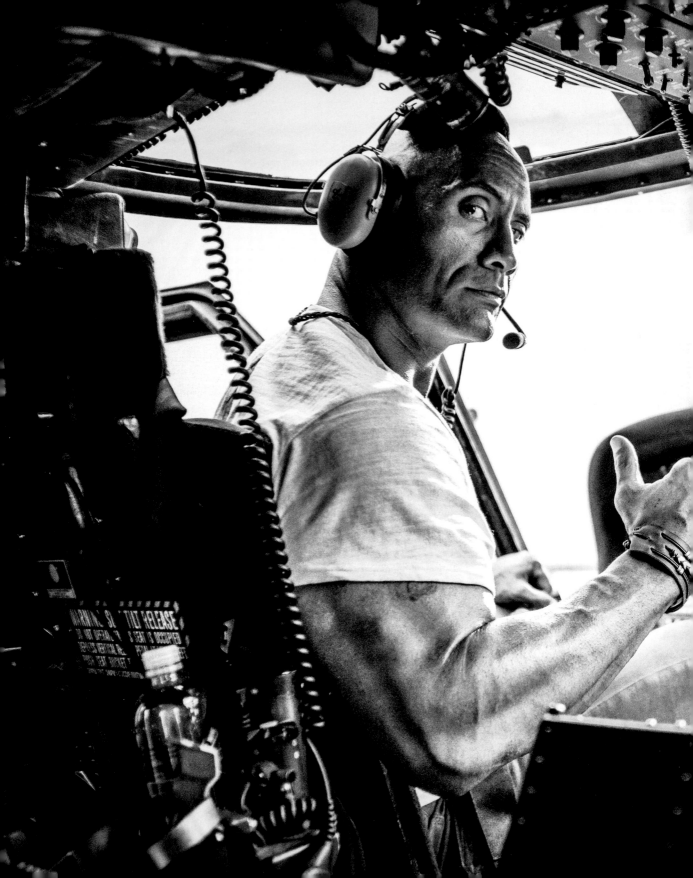

There's a bit of a running joke among our friends that we love to put choppers in our movies. So, naturally, here is a shot of DJ in our *Rampage* chopper.

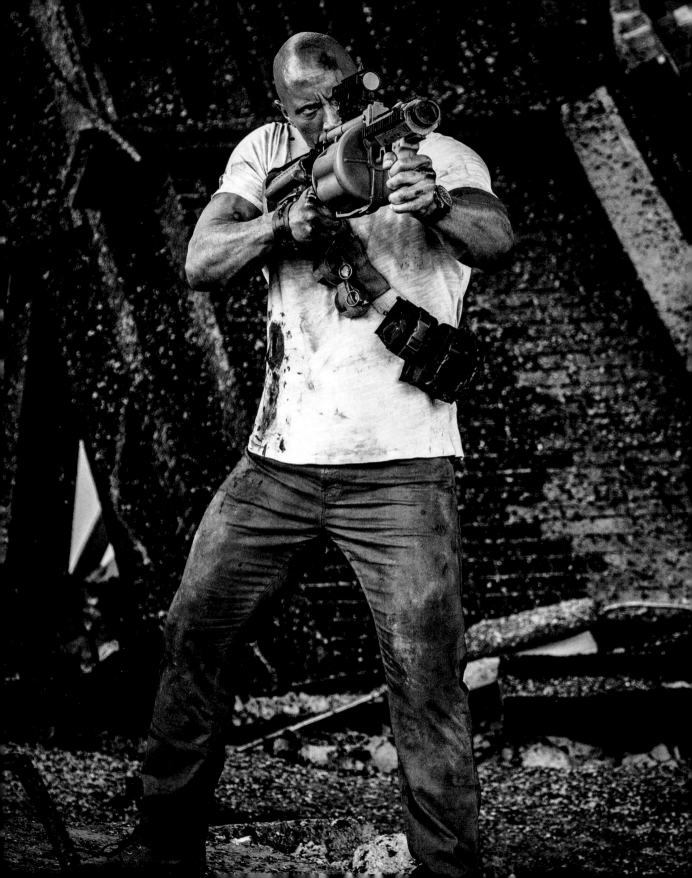

Fighting Lizzie the monster croc in *Rampage*. She wasn't given a name in the script, but game players know her as Lizzie and we called her that, too.

DJ has worked with so many amazing actors, but his chemistry with Emily Blunt on *Jungle Cruise* is like no other. These two light up any room, and watching them on screen together is pure magic.

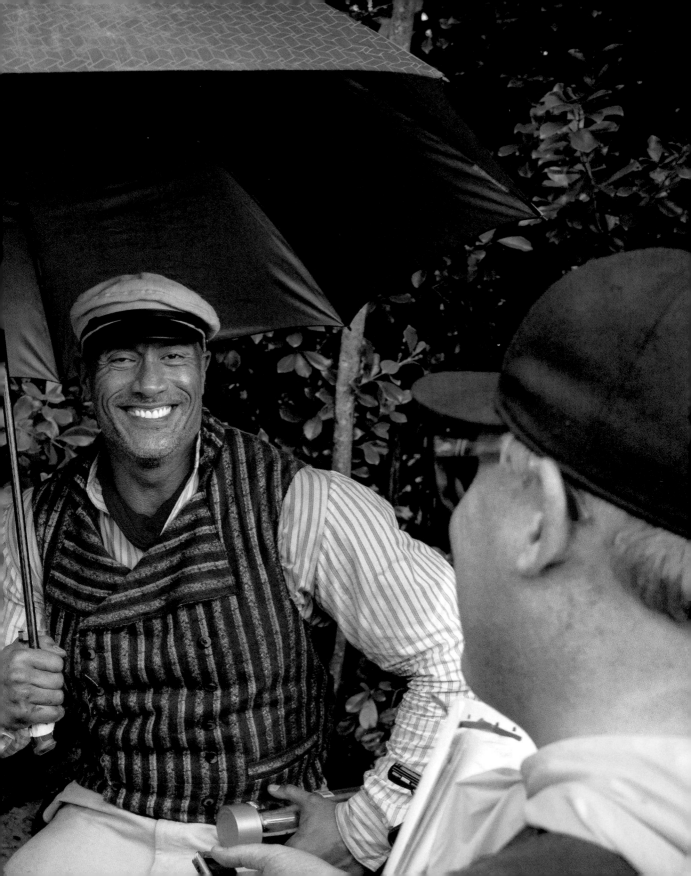

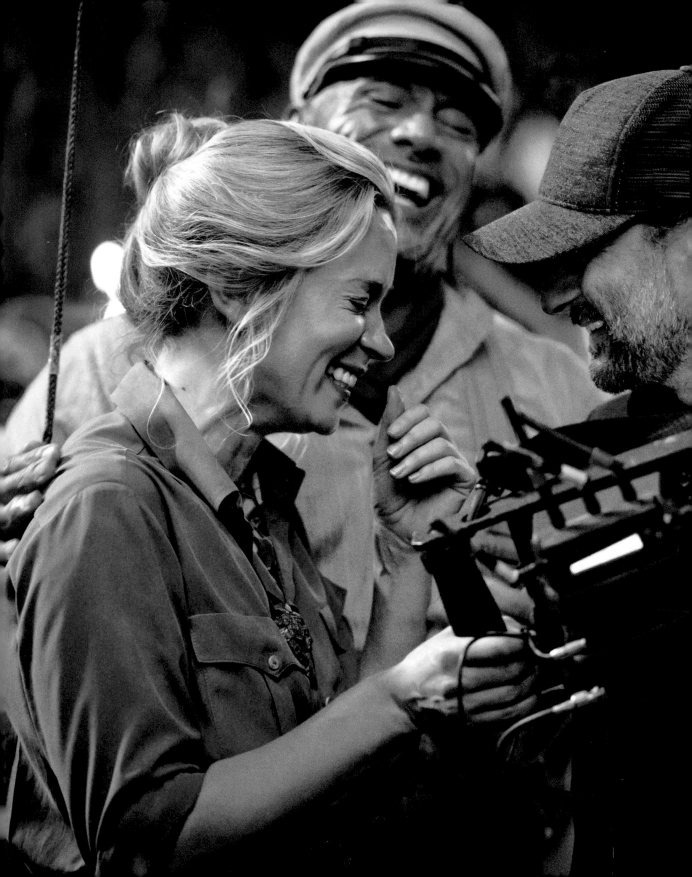

DJ, Emily Blunt, and director Jaume Collet-Serra review play-back during *Jungle Cruise* filming.

DJ and Mark Wahlberg on the set of *Pain and Gain*. DJ's role as Paul Doyle is one of the most daring parts he has ever played, based on a true story of abduction and extortion by a Miami gym owner in the 1990s. At the time, DJ had never played a character like Paul, but director Michael Bay wrote DJ an impassioned email that convinced him to come aboard. Plus, Michael had once made a movie called *The Rock* so it was only fitting that he now worked with The Rock as well!

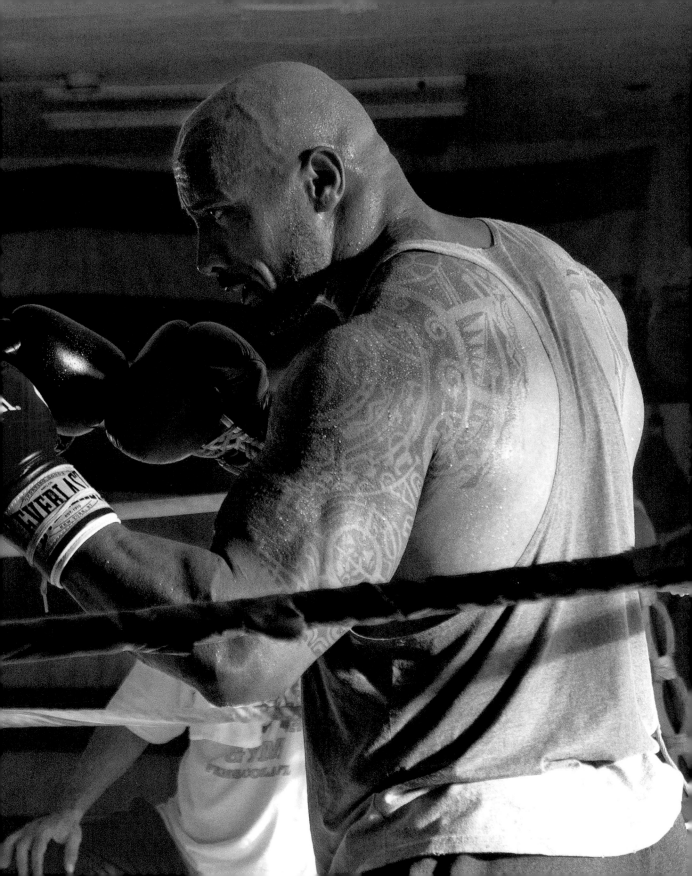

The Fate of the Furious was the first time we introduced Hobbs's Polynesian heritage—which the character shares with DJ—into the Fast world. We'd do it in an even bigger way in *Hobbs & Shaw*. Many of our audiences rated the *Haka* soccer scene in *Furious 8* as one of their favorites in the movie!

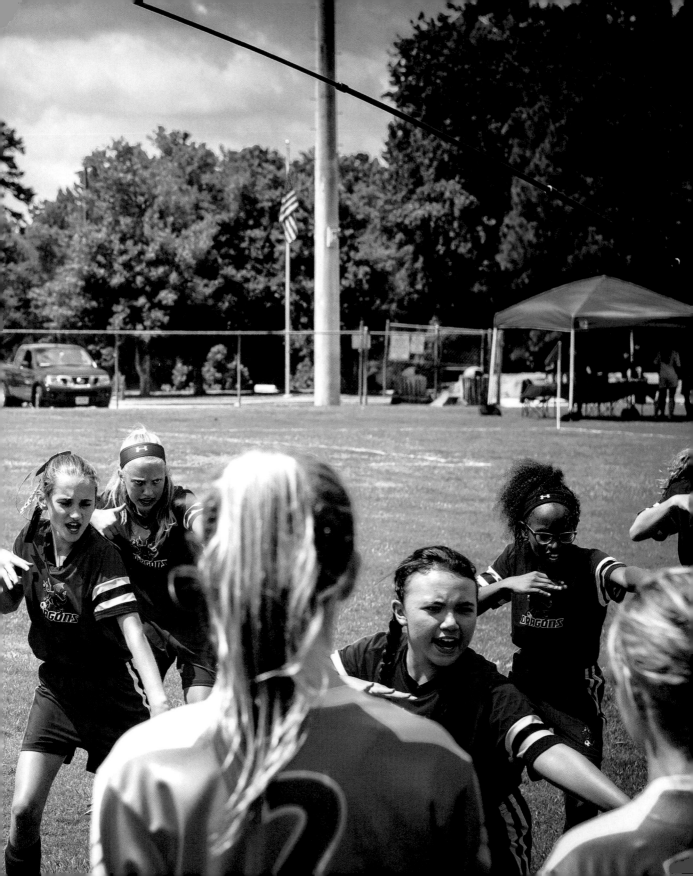

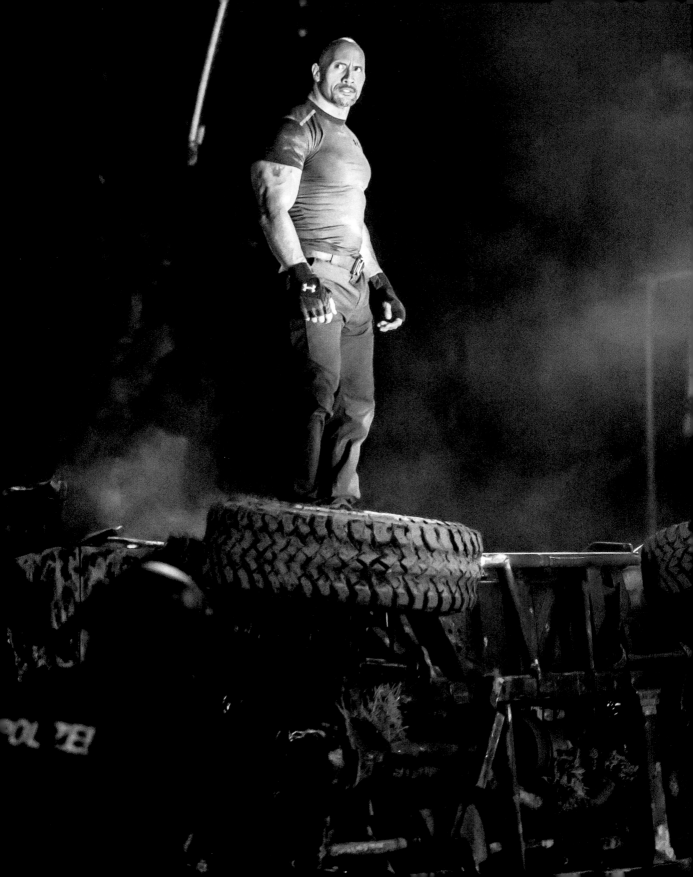

One of my favorite images I've ever taken, from the set of *Fast 8*. The amazing reactions I received from people who saw this shot helped me realize that the hobby I loved so much could turn into something more.

DJ with Ron Meyer, who runs NBCUniversal, when he visited the set of *Hobbs & Shaw*. DJ has incredible relationships with studio heads, but none better than his long friendship with Meyer. You'll understand how close they are when I tell you that DJ calls Meyer "Uncle Ronny"!

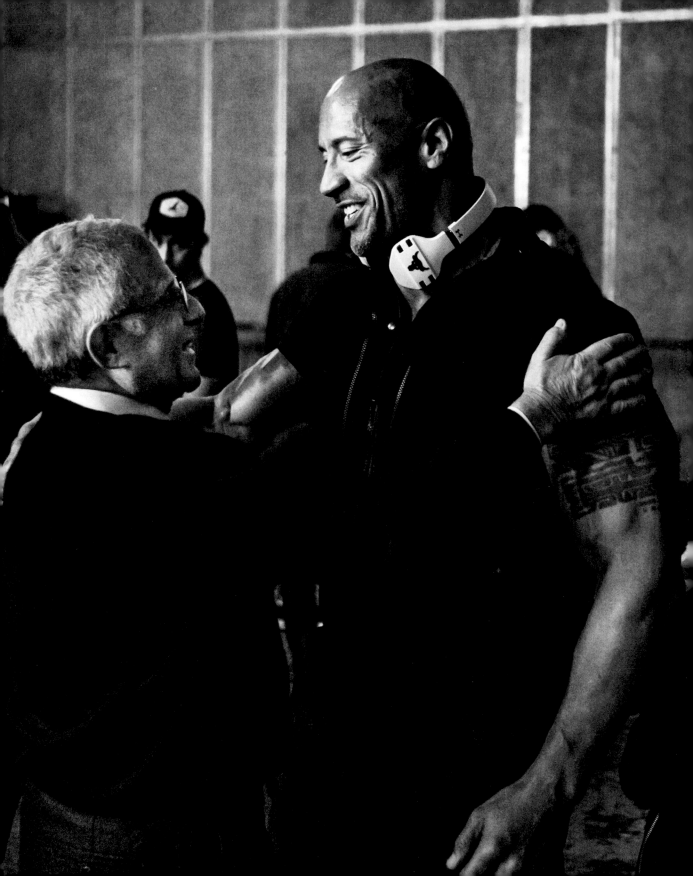

When you're an action star you owe a great deal of gratitude to the many stunt people who help bring the movies to life. Here is a perfect example of what a great stuntman can do to help elevate a scene.

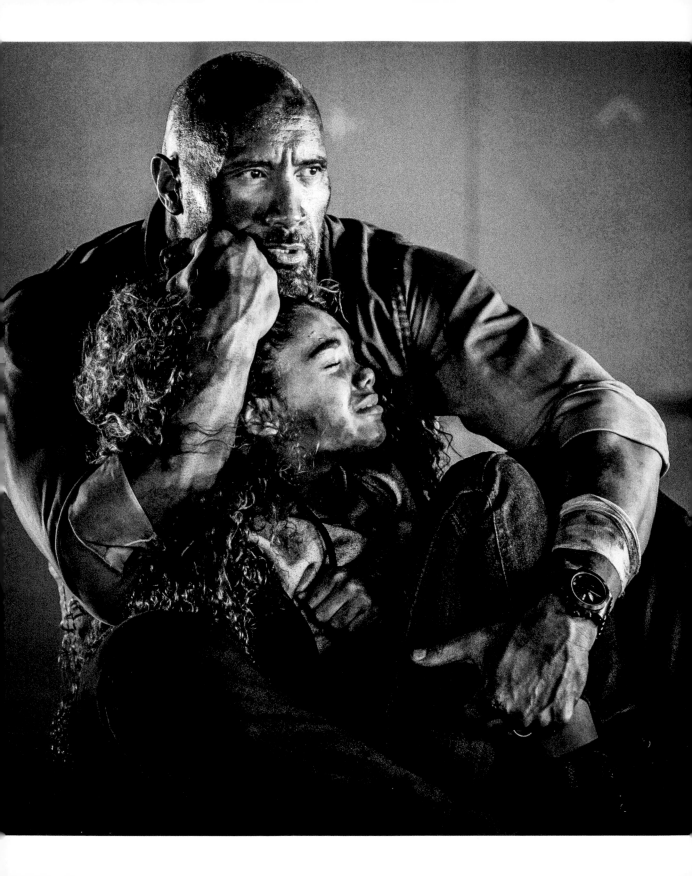

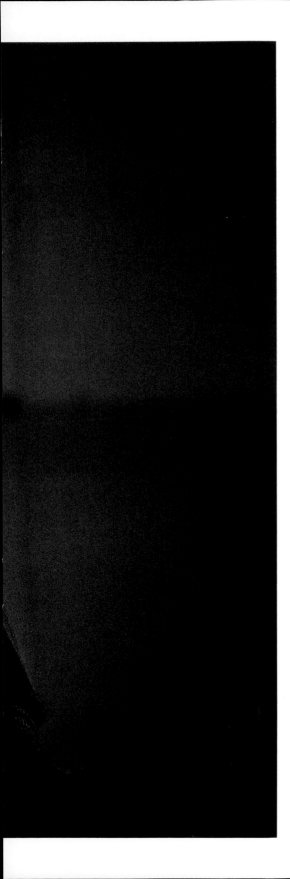

With McKenna Roberts
on the *Skyscraper* set.

DJ and Idris Elba getting wet down before a *Hobbs & Shaw* scene. The rain machine was running through very old and cold pipes during the winter in London. This shot of them laughing is a testament to just how good-natured both these stars are, considering the water was absolutely freezing!

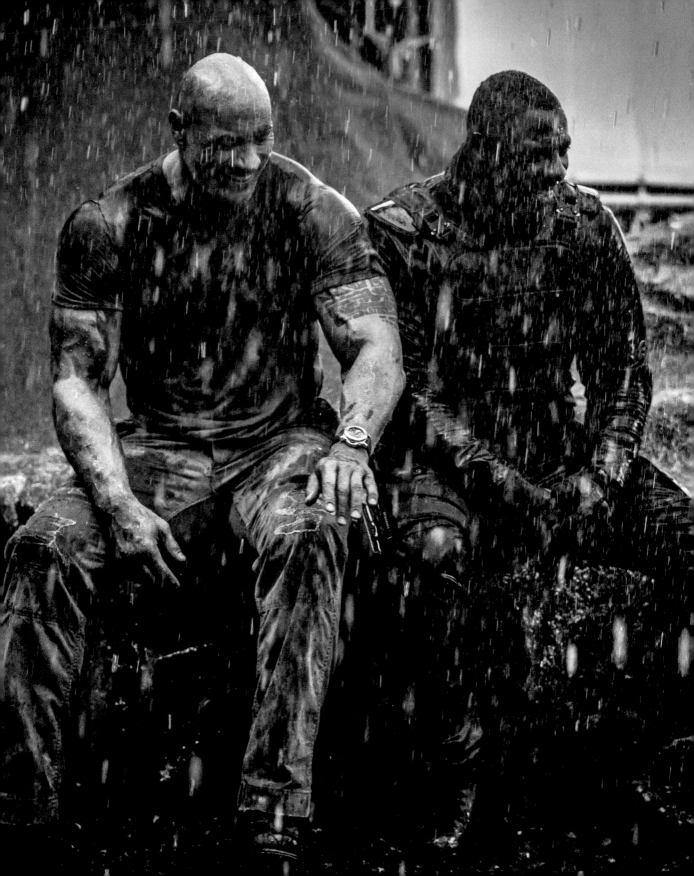

DJ and Emily Blunt share a sense of humor—and the laugh to prove it—between takes on *Jungle Cruise*.

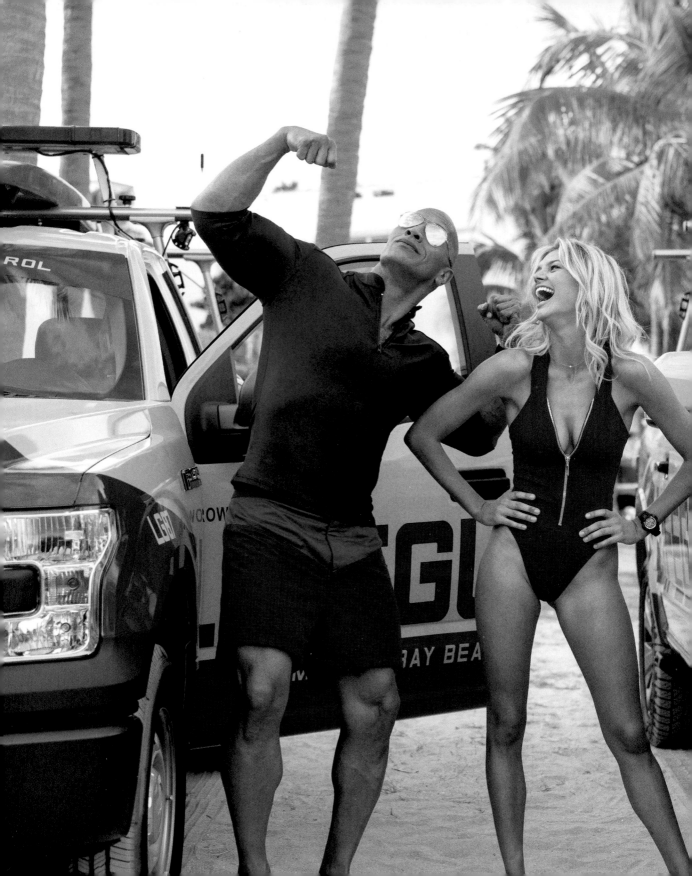

DJ loves to catch people off-guard and create an organic moment of humor. He knew his *Baywatch* co-star Kelly Rohrbach wouldn't be able to keep a straight face.

With Ryan Reynolds, who was making a surprise cameo, on the set of *Hobbs & Shaw*. This scene made us realize Ryan would be perfect starring with DJ in *Red Notice*, which we were just starting to cast.

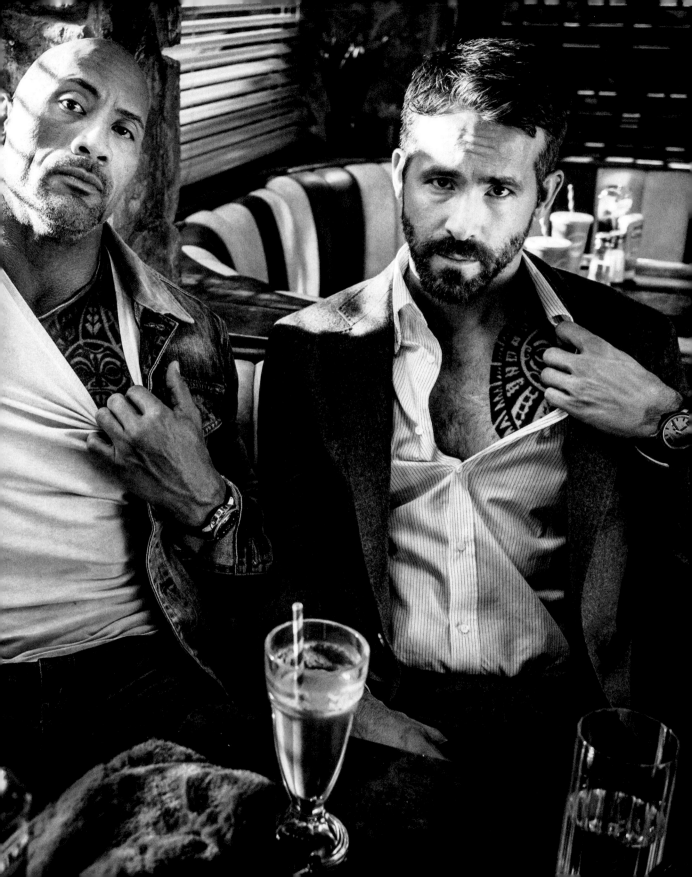

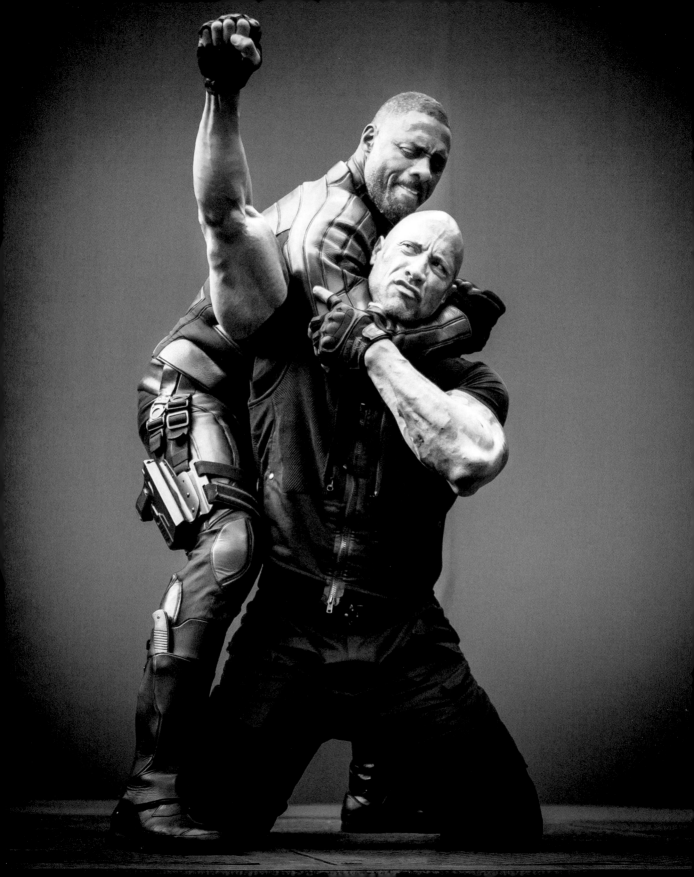

In wrestling, you make your opponent look good by letting him kick your ass early in the competition. Here DJ makes sure Idris puts him in a great chokehold. DJ couldn't resist popping a defiant fist for a laugh, though, once the cameras started rolling!

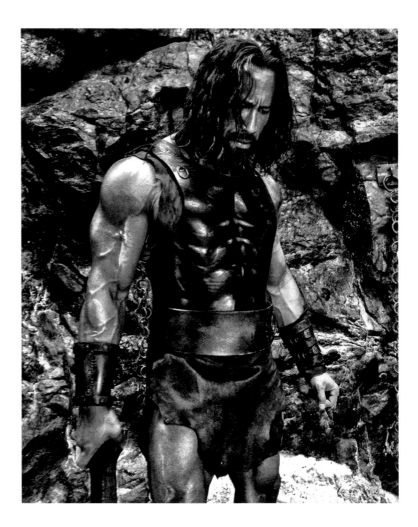

Right before filming started on *Hercules*, DJ sustained two hernias and a serious quad tear during Wrestlemania. We ended up having to push production, but that didn't deter DJ from wanting to achieve a physique even he had never had before. This shot is of one of the first times DJ put on his Hercules costume and became the demi-god.

This picture is from the set of *Hercules* in Budapest. No matter what's going on, DJ will always take a moment out to say hi to visiting kids. This was a cute moment I was able to capture of him playing pat-a-cake with West, the daughter of our longtime producing partner and friend Beau Flynn.

This was the first time DJ and the legend
that is Danny DeVito, cast in *Jumanji:
The Next Level,* met. They hit it off instantly.
I was glad to be able to grab this shot of
them walking down the hallway.

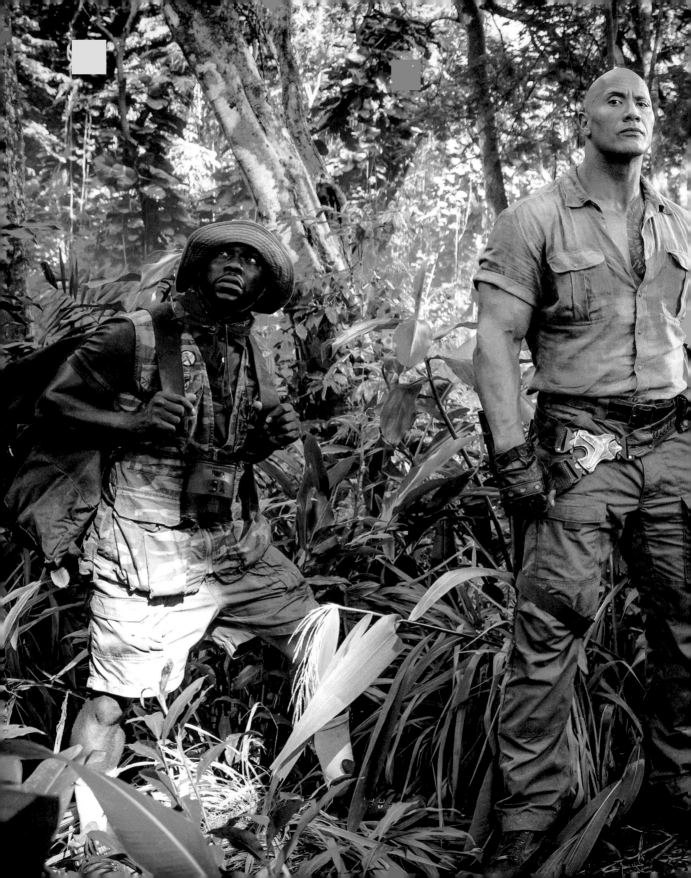

The *Jumanji* team from *Welcome to the Jungle.*

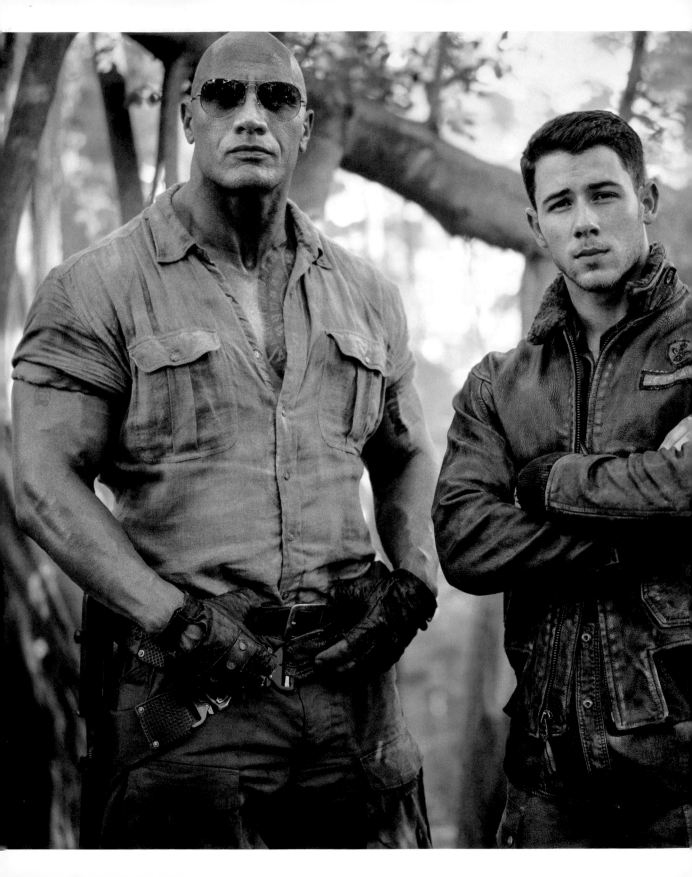

The Rock and Nick Jonas in *Jumanji: Welcome to the Jungle.*

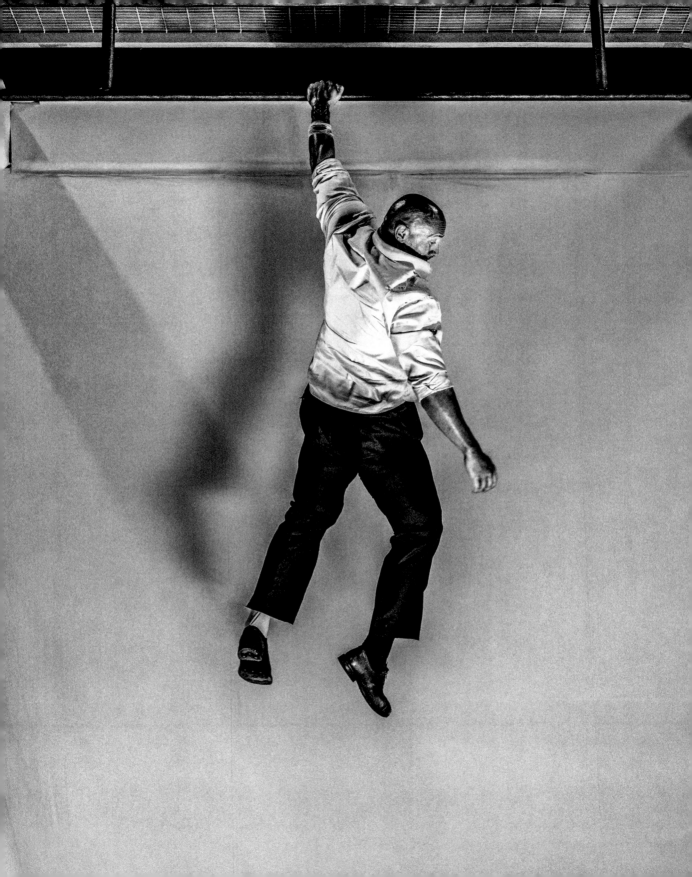

Hanging from what would become
a giant crane in *Skyscraper*.

DJ and Emily Blunt hanging around
on the set of *Jungle Cruise*.

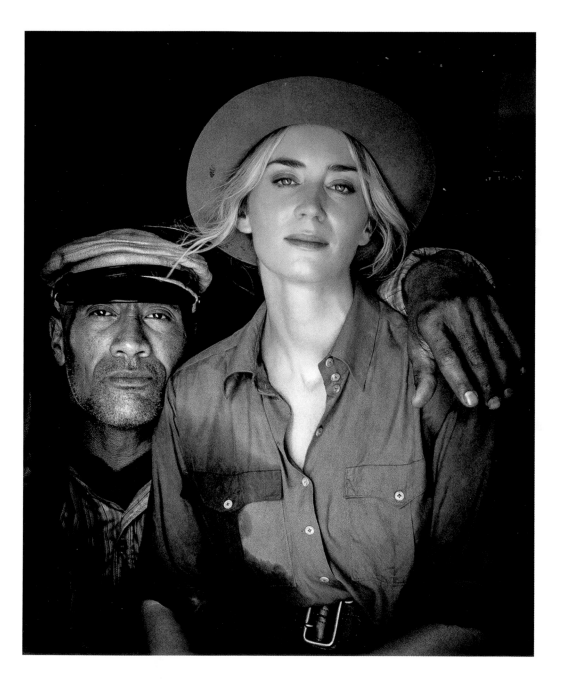

Laying down a song written by the Oscar-winning composers Kristen Anderson-Lopez and Robert Lopez for *Jungle Cruise.*

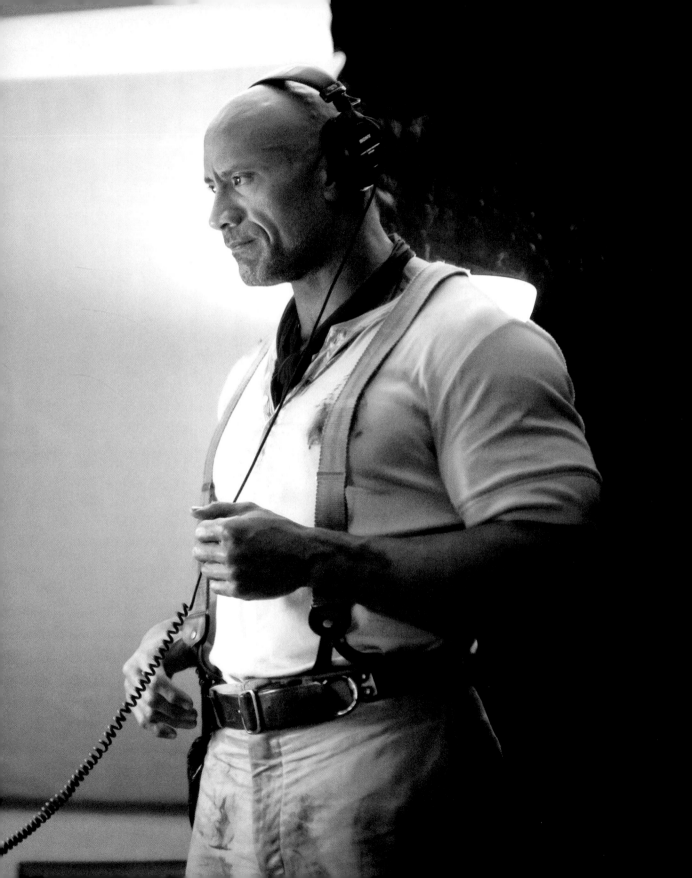

Read-throughs aren't
ever a chore when
you're on a movie with
the great Danny DeVito.

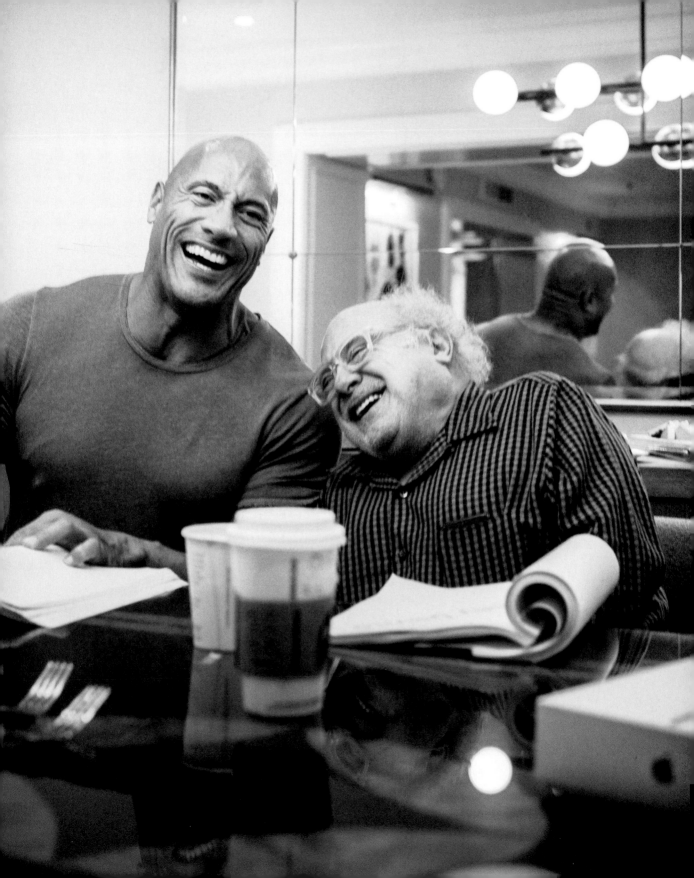

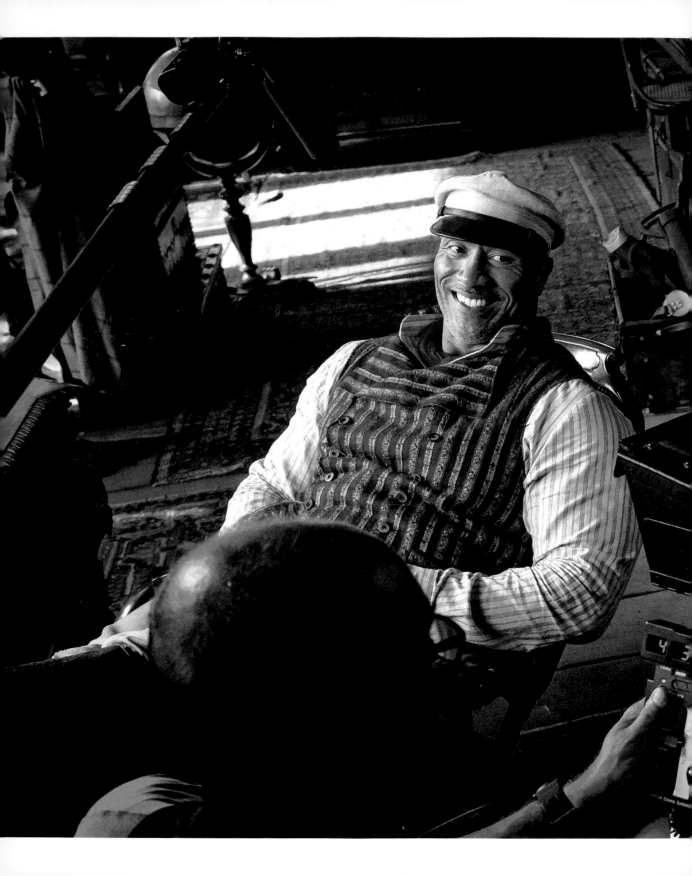

Behind the scenes on *Jungle Cruise* when we were shooting in Kauai.

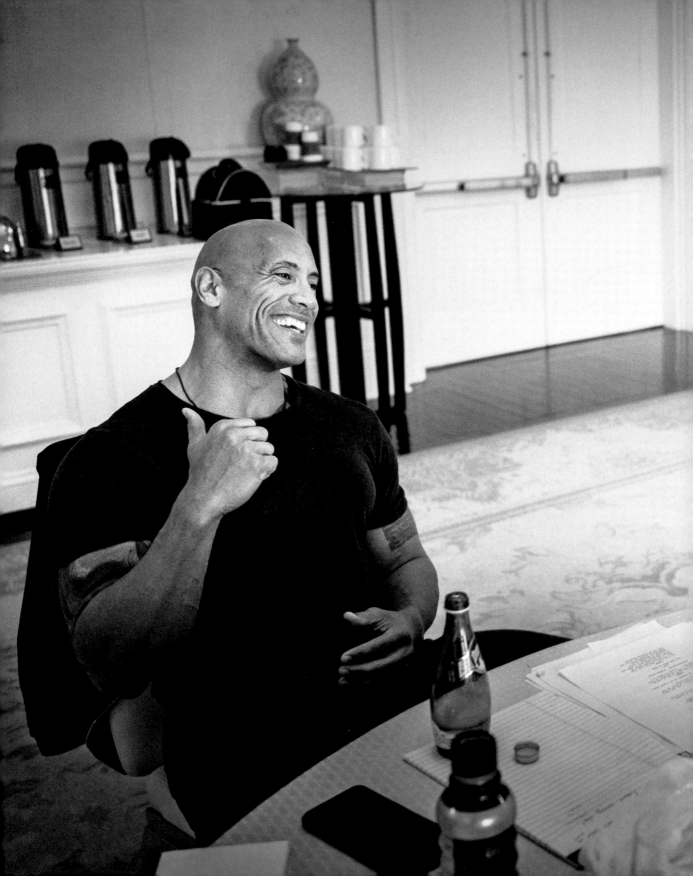

DJ and Emily reading through new script pages when there was a call for additional photography for *Jungle Cruise*.

DJ and Karen Gillan between takes on the set of *Jumanji: The Next Level.*

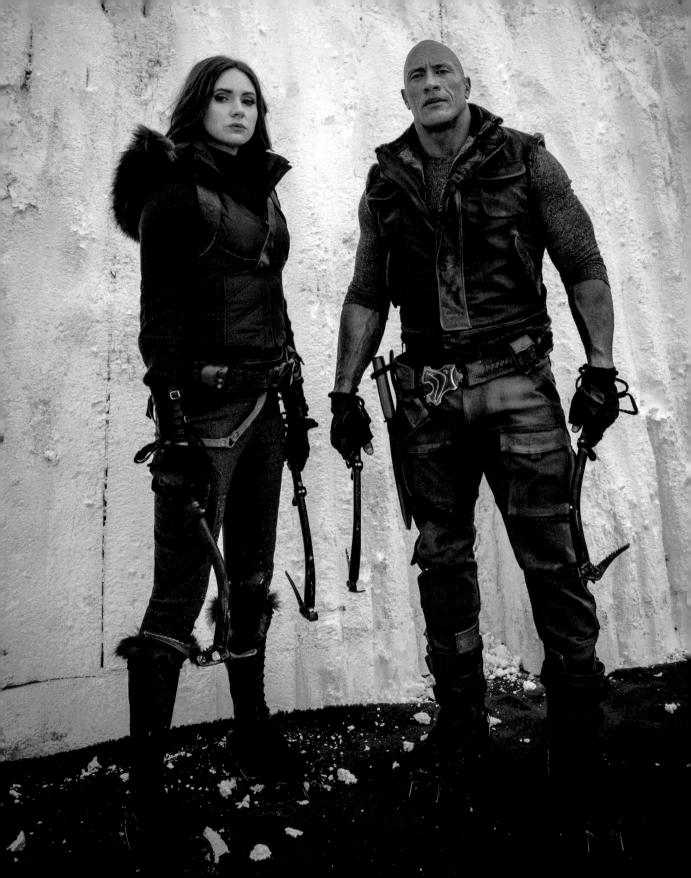

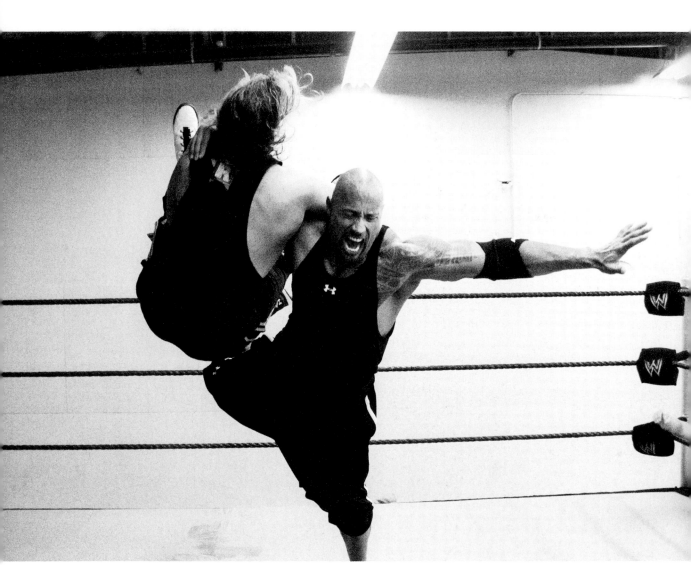

In the wrestling business, every performer has a special finishing move. DJ's is "The Rock Bottom." In this snap, he's delivering his iconic finisher to a sparring partner as he trained in 2012 to get back into the WWE ring.

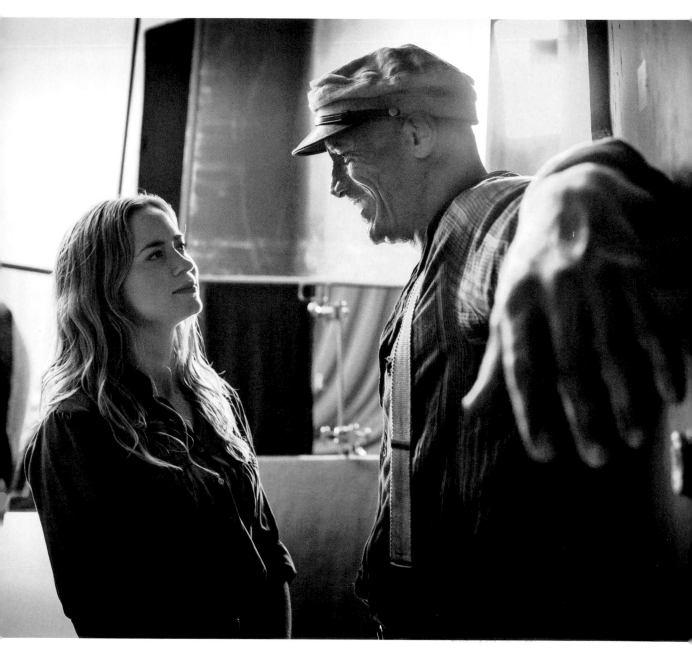

DJ and Emily Blunt as Frank and Lily in *Jungle Cruise*.

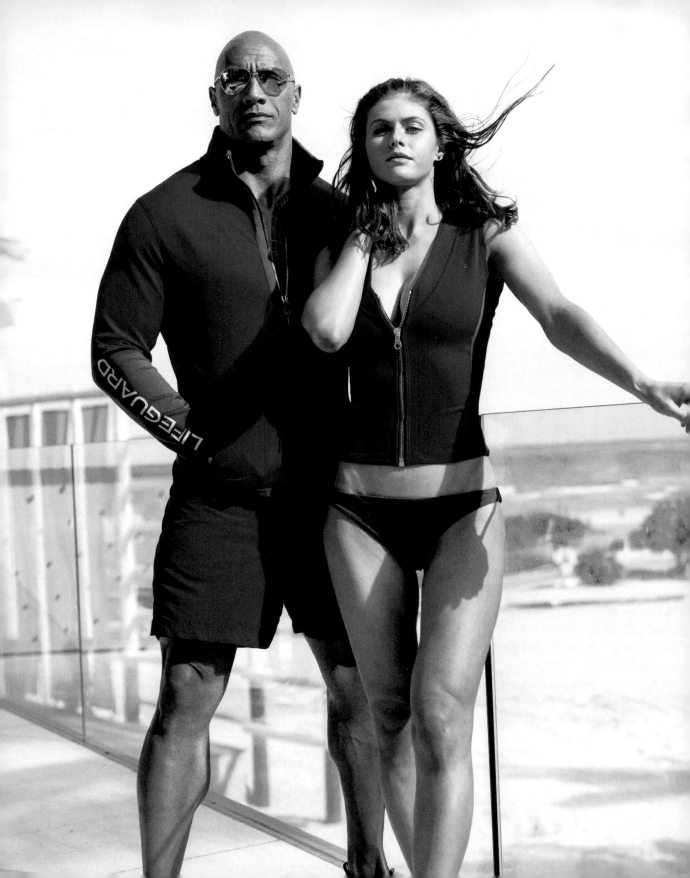

This shot of Alex Daddario and DJ from *Baywatch* was inspired by the comics done by artist Alex Ross: he draws his characters with chins slightly raised and eyes looking down toward the reader. I got such a great response to this photo that I started spending more time on my photography. This is still one of my favorite shots I've ever taken.

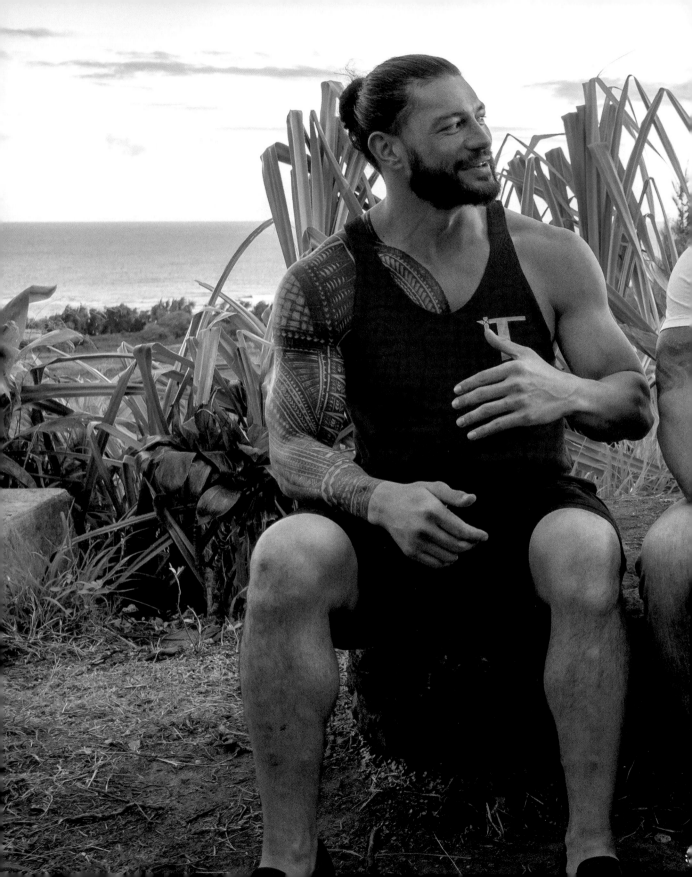

We cast DJ's cousin Joe—aka Roman Reigns—as one of his brothers in *Hobbs & Shaw* as one way to showcase DJ's Samoan heritage in the movie. Joe had just recovered from a bout with leukemia; we felt particularly lucky to have him as part of the film.

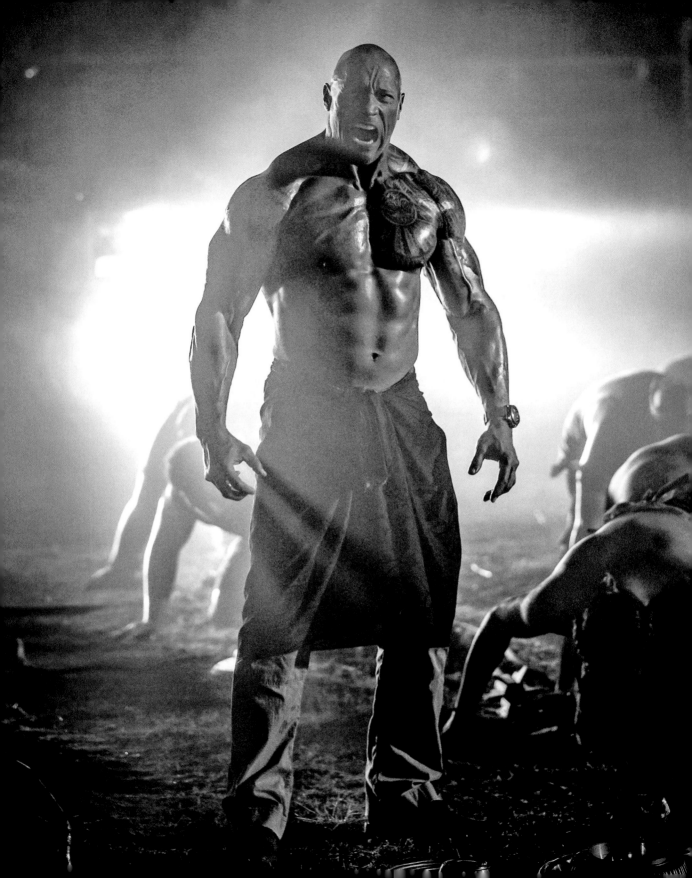

This night shoot on *Hobbs & Shaw* stood out: as part of our initiative to showcase DJ's Samoan culture, he and his brothers performed a Siva Tau (war dance) before the big battle. The set was electric with Mana (magical power) that night; DJ was physically on another level.

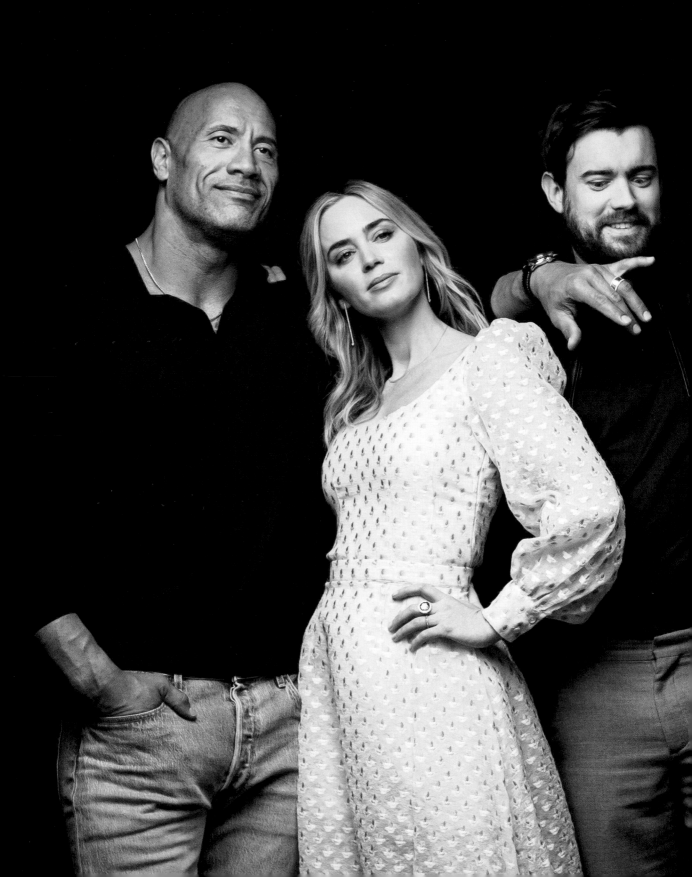

Actors are constantly doing photo shoots for promotions, and it can get a bit monotonous. These are the moments when DJ can't resist spiking the atmosphere with a bit of fun. During a photo shoot with Emily Blunt and Jack Whitehall I could sense DJ was planning something. Luckily I caught the moment where he tried to get Jack to laugh.

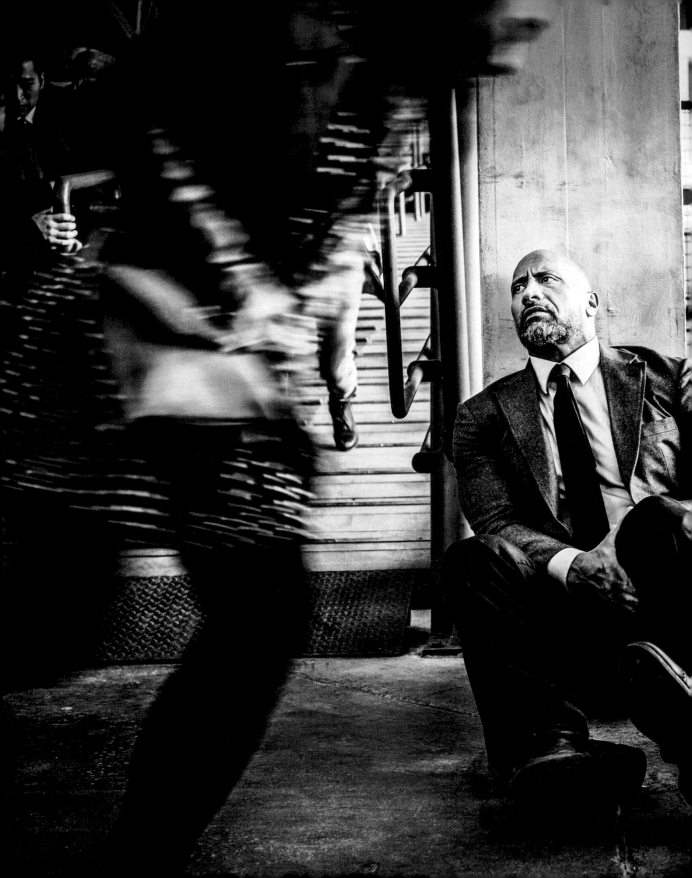

The Rock in *Skyscraper*.

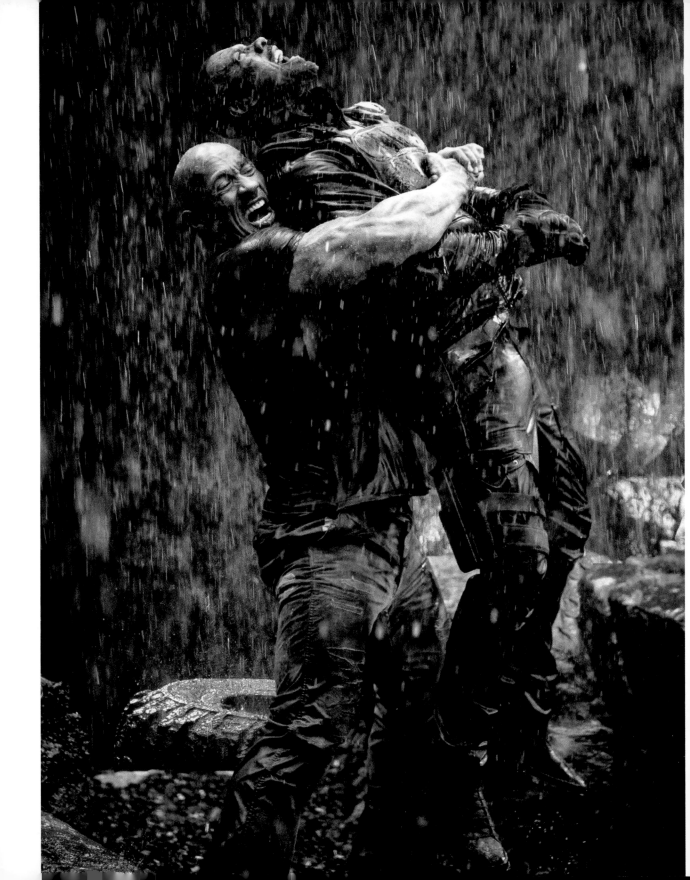

Preparing to put the final blow on Idris Elba in the form of a belly-to-back suplex for *Hobbs & Shaw*. Idris was such a pleasure to work with; we can't wait to work with him again.

DJ and Kevin Hart are best friends who share an incredible work ethic and what some might call an inappropriate sense of humor. I love capturing these two crack each other up.

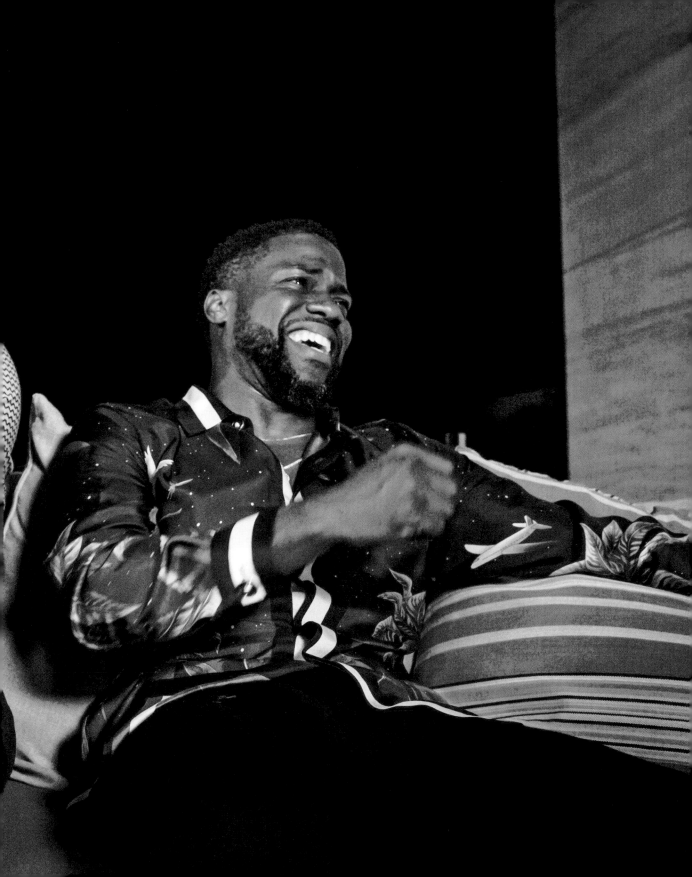

When you're a mega-star in the middle of a press tour, many people are involved. During international press for *Hobbs & Shaw* I couldn't resist snapping this pic in a packed elevator as DJ stood head and shoulders above publicists, hospitality escorts, studio reps, assistants, and more, calmly waiting for the chaos that would ensue once those doors opened.

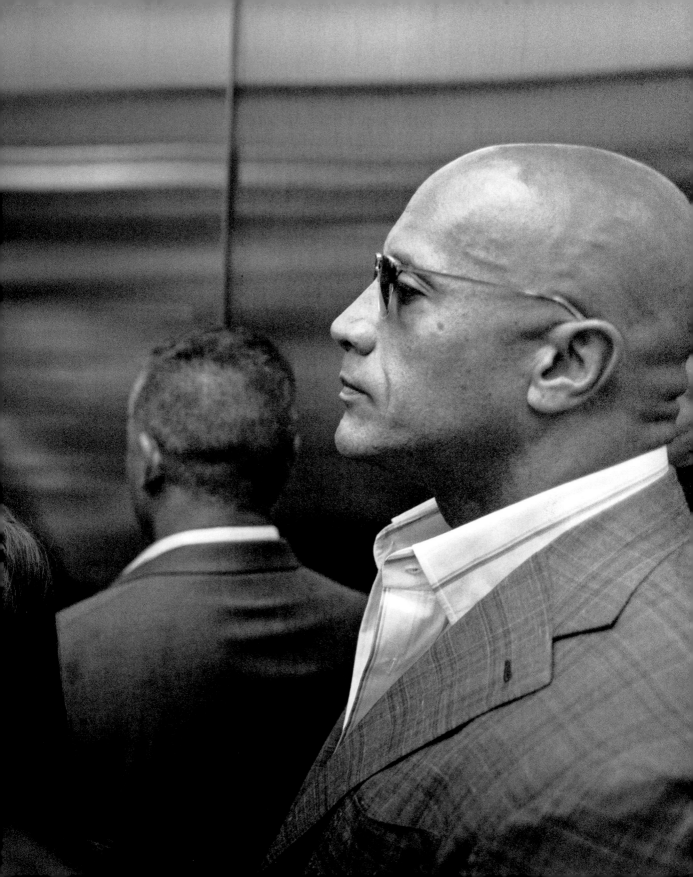

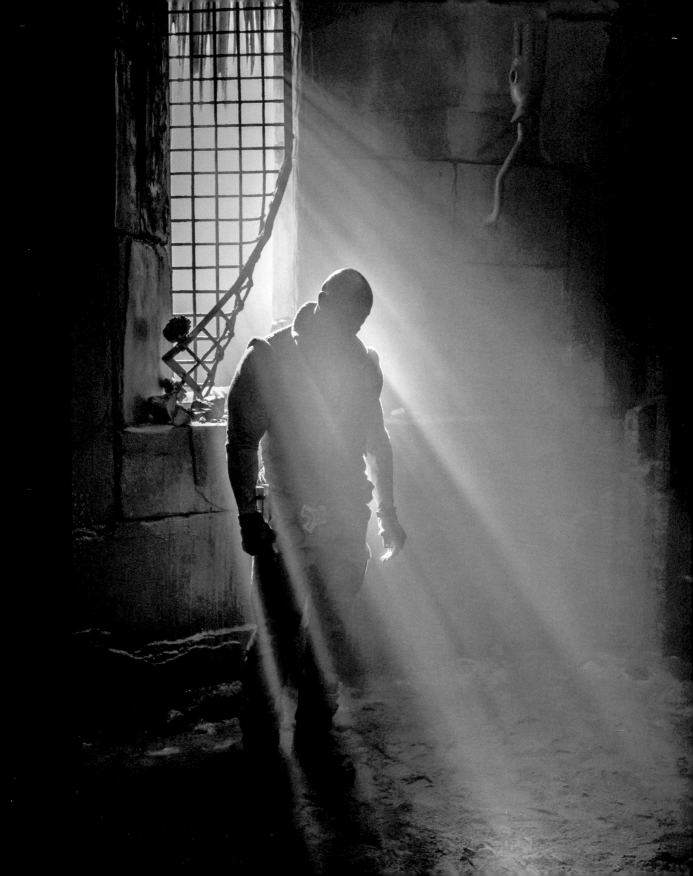

Waiting to hear "action" on the set of *Jumanji: The Next Level.*

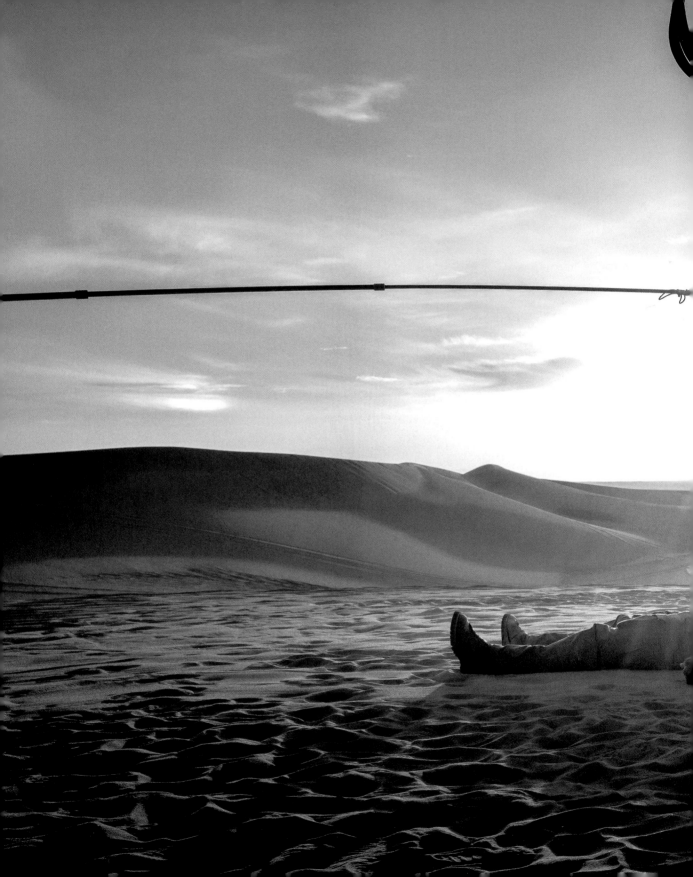

On location in Glamis, California, for *Jumanji: The Next Level.*

Nothing's more fun than
displaying examples of Hobbs's
comic-book strength.

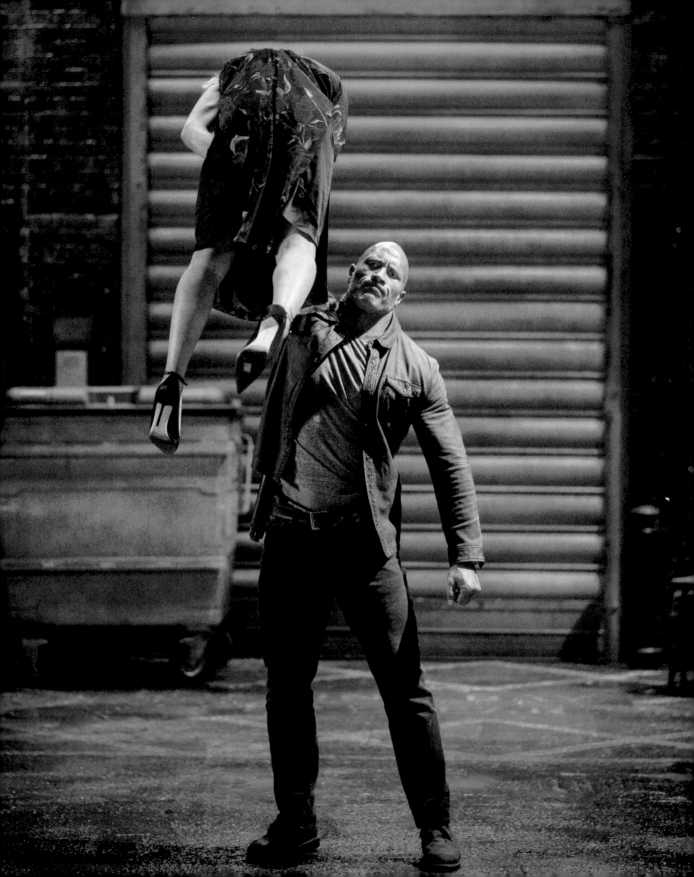

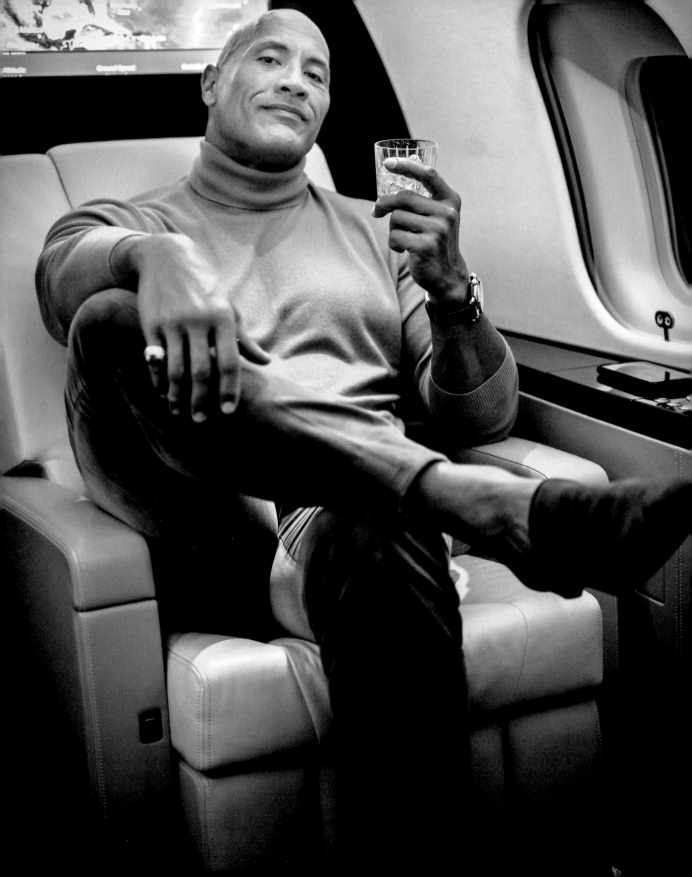

PART THREE

In His World

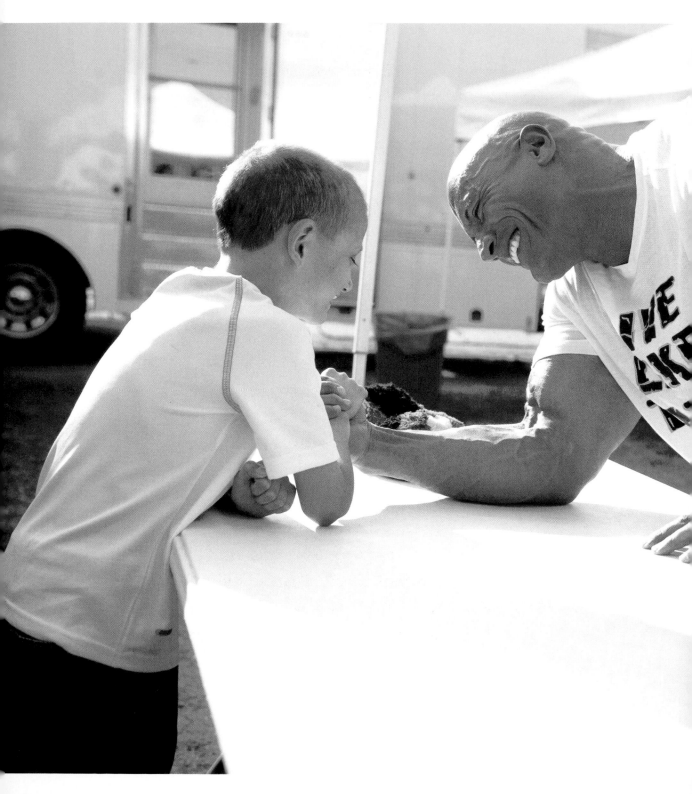

DJ loves kids and loves making them smile. No matter what's happening, he'll always stop if he sees an opportunity to bring a child joy, especially when life's dealt them a tough hand. We were shooting *Baywatch* when an outpouring of messages told us about Gabriel "Tater" Singleton. Tater was an unbelievably vibrant kid who had been battling neuroblastoma for too many years of his young life. He wanted to meet DJ, and DJ wanted to meet Tater, too. He and Tater spent the day on set; they had lunch and arm-wrestled and made each other laugh all day long. DJ always says that interacting with fans is the best part of his day, and that day with Tater will always be one of his favorites. R.I.P. Tater.

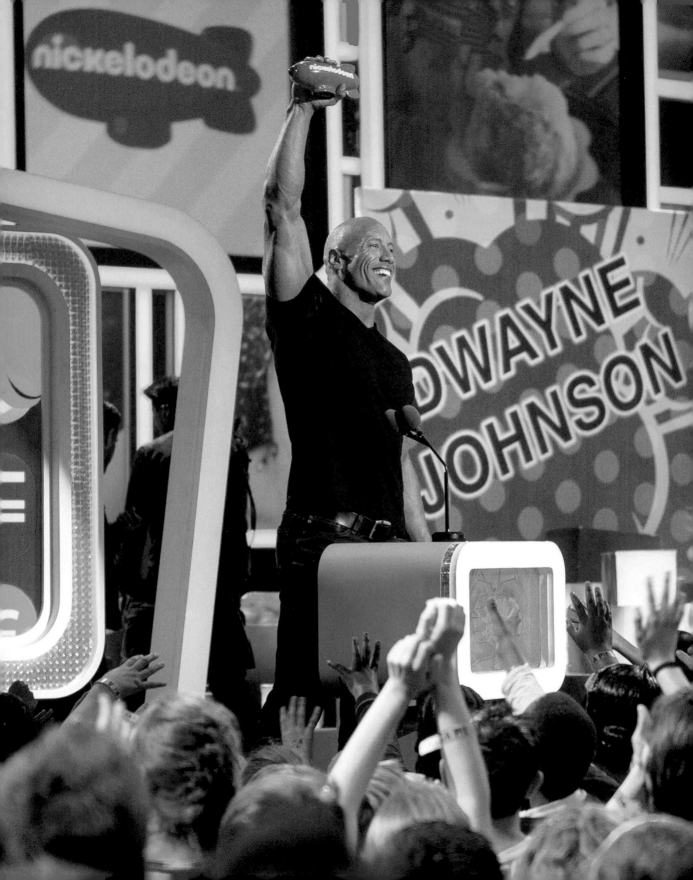

Nickelodeon Kids'
Choice awards.

DJ is always extra
alive on a fan line!

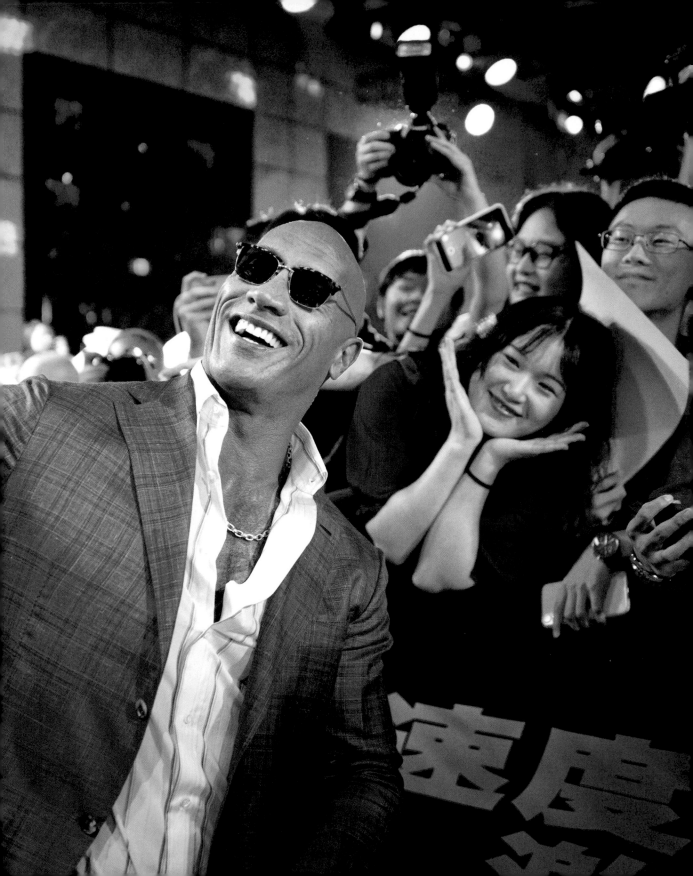

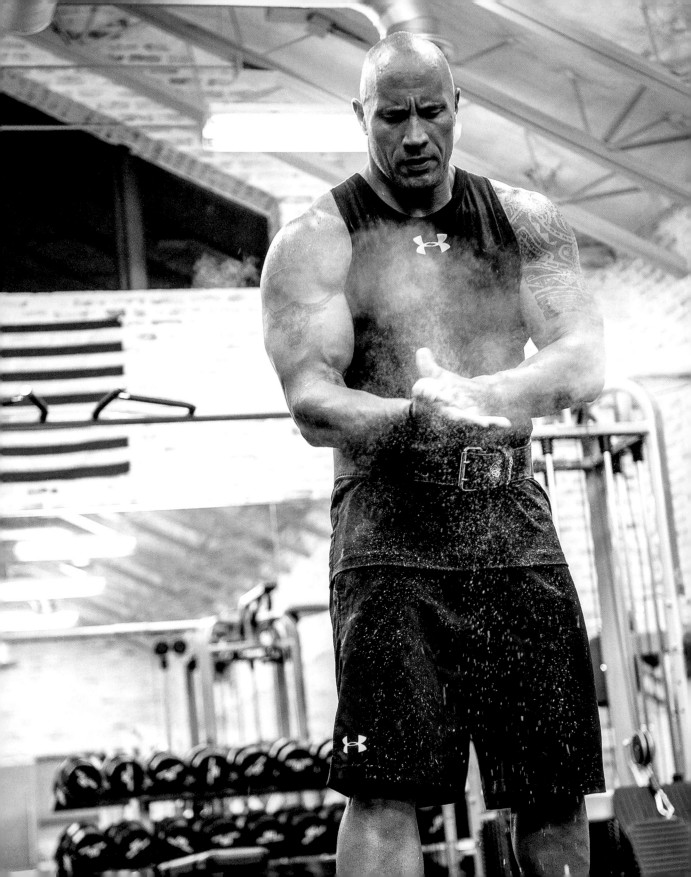

For many years, DJ and Under Armour
had a great relationship, but had never
formally been in business together.
I shot this one at one of the first
Under Armour shoots DJ did.

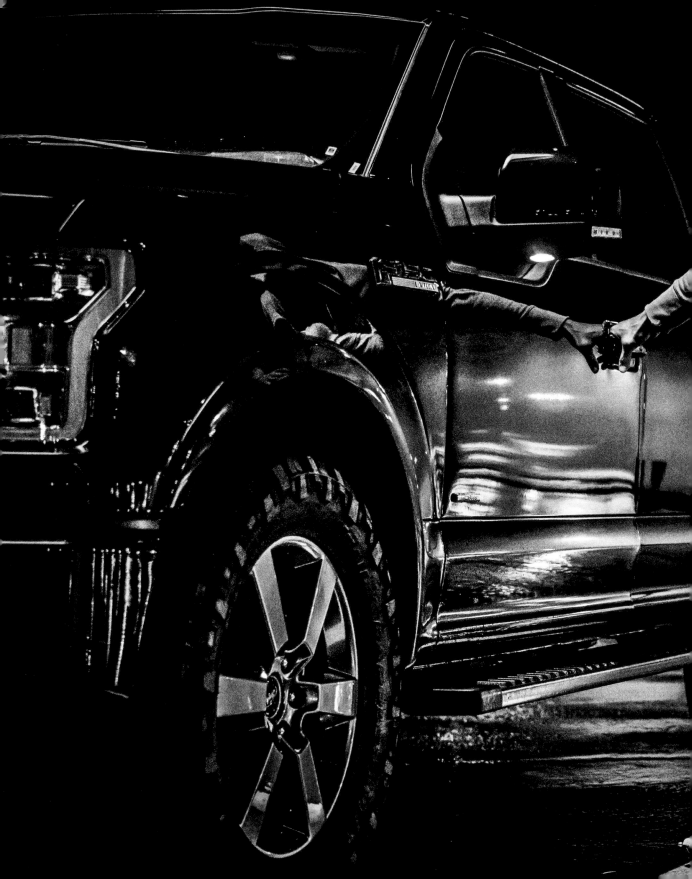

Putting together
a commercial for
Under Armour.

The Tonight Show Starring Jimmy Fallon has always been one of DJ's favorite talk shows to visit—could it be because Jimmy always wants to do something crazy? Here the guys dressed up and walked out into Universal Studios surprising fans on a tour.

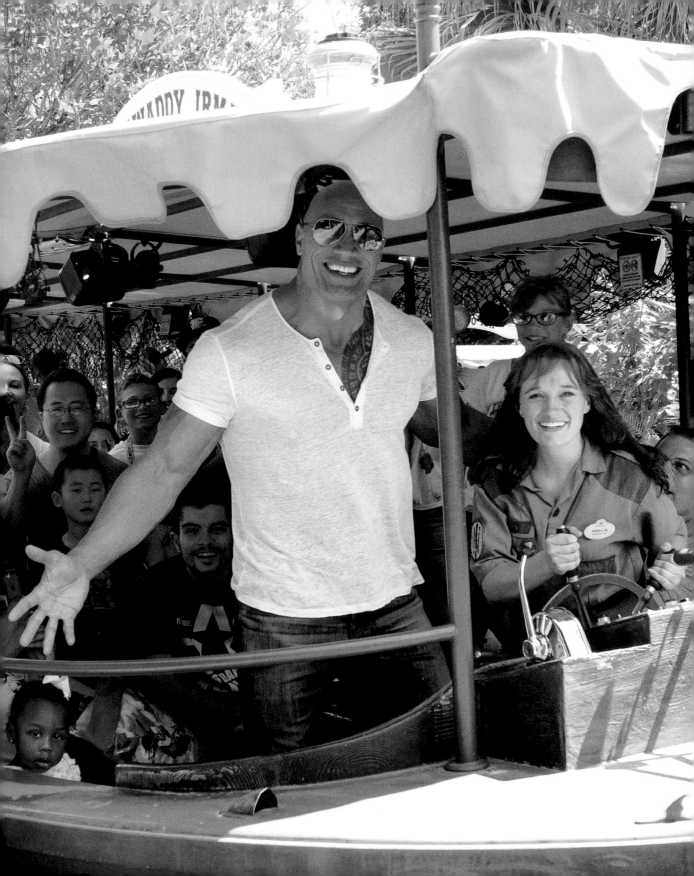

Ever since DJ saw the first *Pirates of the Caribbean* trailer, he put starring in a movie based on a Disney ride on his bucket list. And the ride he always wanted to bring to the screen was *Jungle Cruise*. DJ was so excited that everything was coming together that he surprised a regular Jungle Cruise ride at Disney World to announce the movie.

When promoting a project, press days can become a whirlwind of activity with very little down time. Here DJ catches up on some work during a twenty-minute lunch break during a press run in NYC.

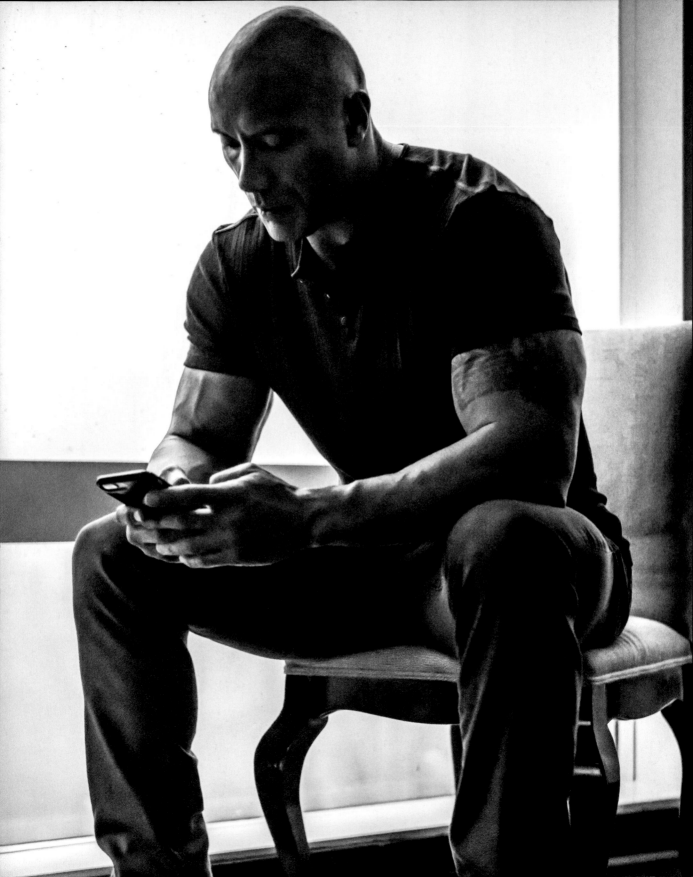

DJ performing his iconic "If ya smellllllll . . . " much to Jamie Foxx's delight in an appearance on his show.

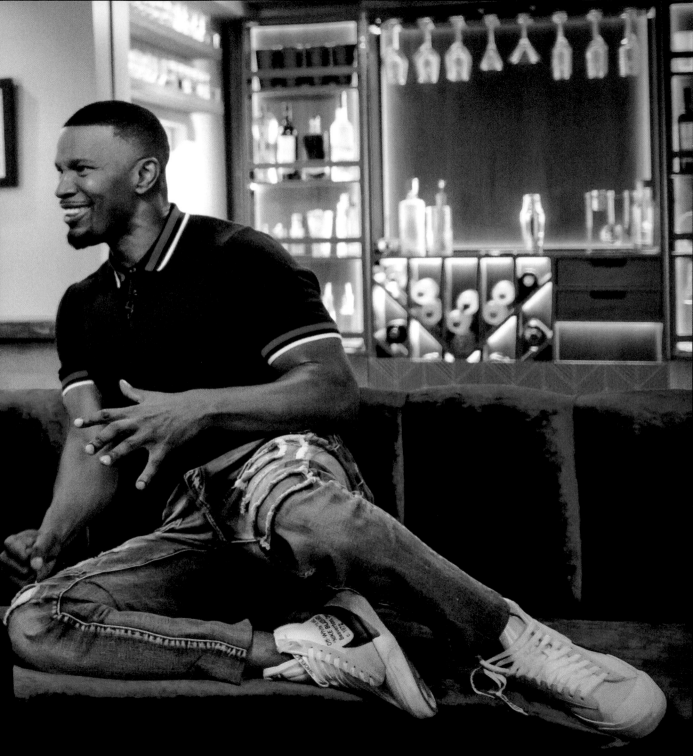

Some of The Rock's favorite appearances on *Saturday Night Live* have been with the great Bobby Moynihan. This one was a spoof of an ad for a male enhancement drug. DJ "got his confidence back" so successfully that he's hosted *SNL* five times.

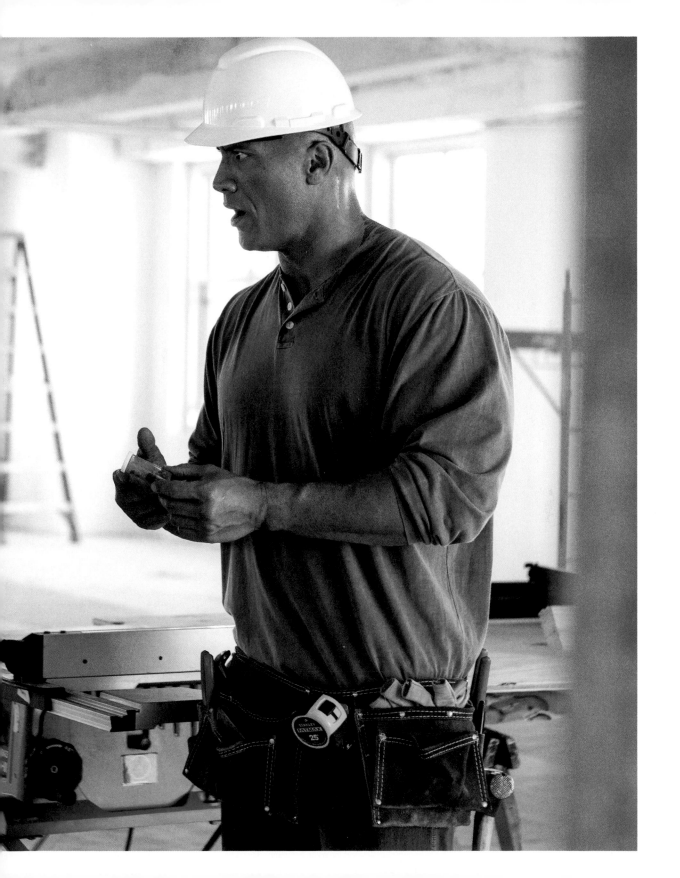

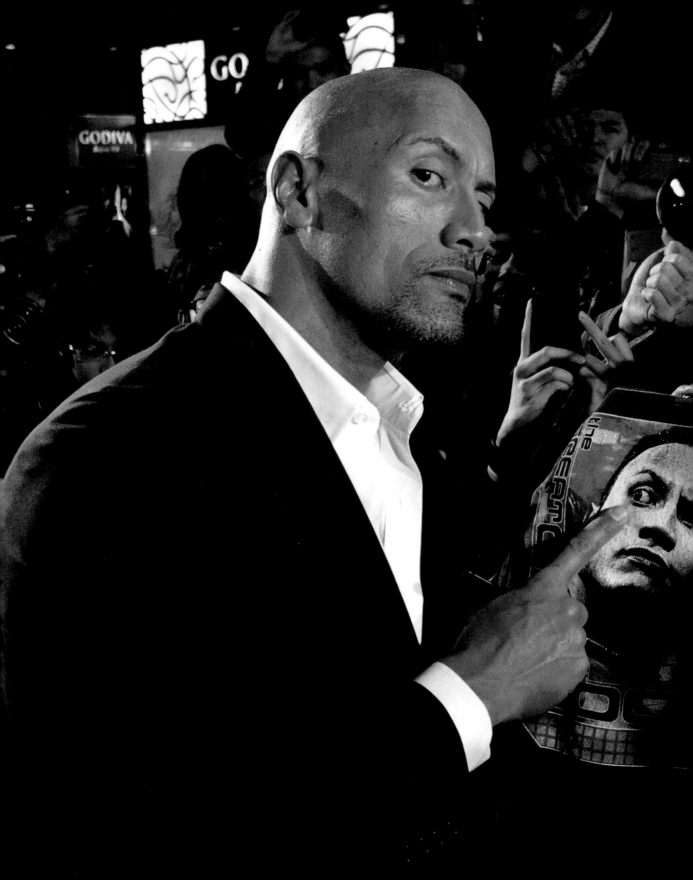

DJ loves spending time at fan lines at premieres,
but he gives extra love and attention to fan art.

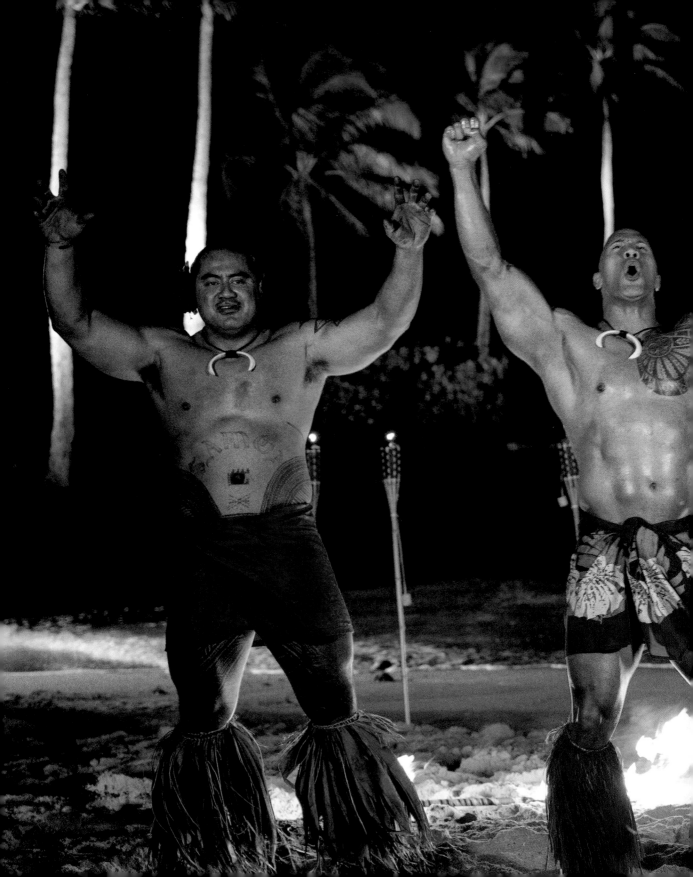

Promoting *Moana* on *Good Morning America*.
DJ loves showcasing his Samoan background
and introducing the world to its culture.
Moana, set entirely in Polynesia, was
the perfect opportunity.

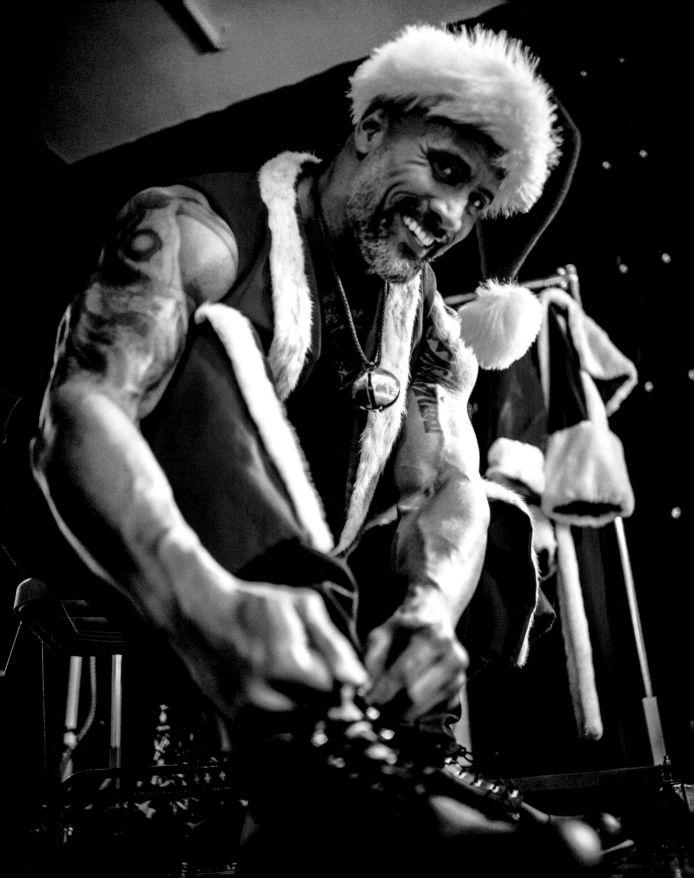

DJ came up with the alter ego of Dwanta Claus
to bring gifts and surprises to fans at Christmas.
Here he is suiting up for a *Rolling Stone* shoot.
Don't forget that Dwanta Claus wants you to
leave him some tequila instead of milk
along with those cookies!

In partnership with Spike TV, DJ and Seven Bucks put on a record-breaking holiday special called "Rock the Troops" that we filmed at Joint Base Pearl Harbor–Hickam in Hawaii to honor service men and women. This is a behind-the-scenes shot from the promotional photo shoot, done weeks before the stars and bands hit the stage in Hawaii.

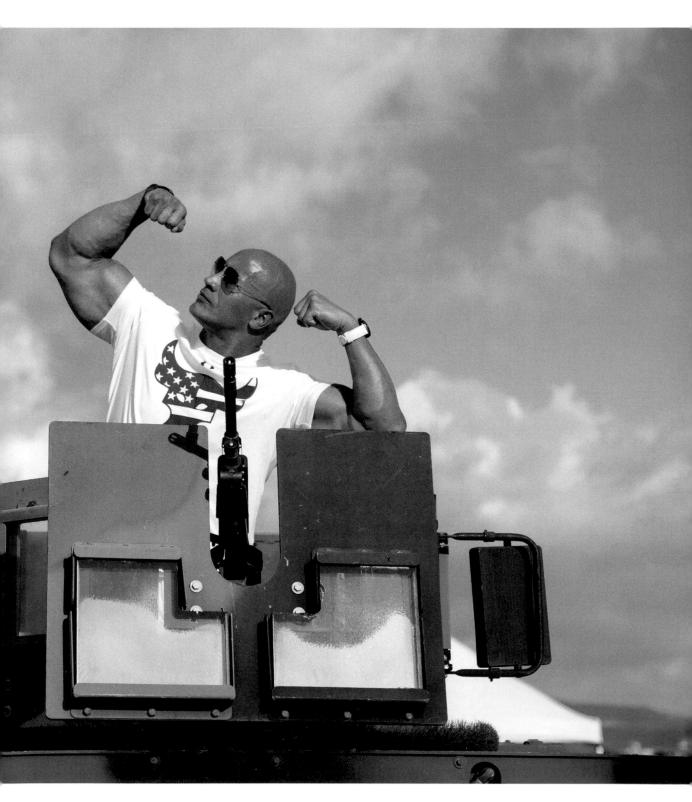

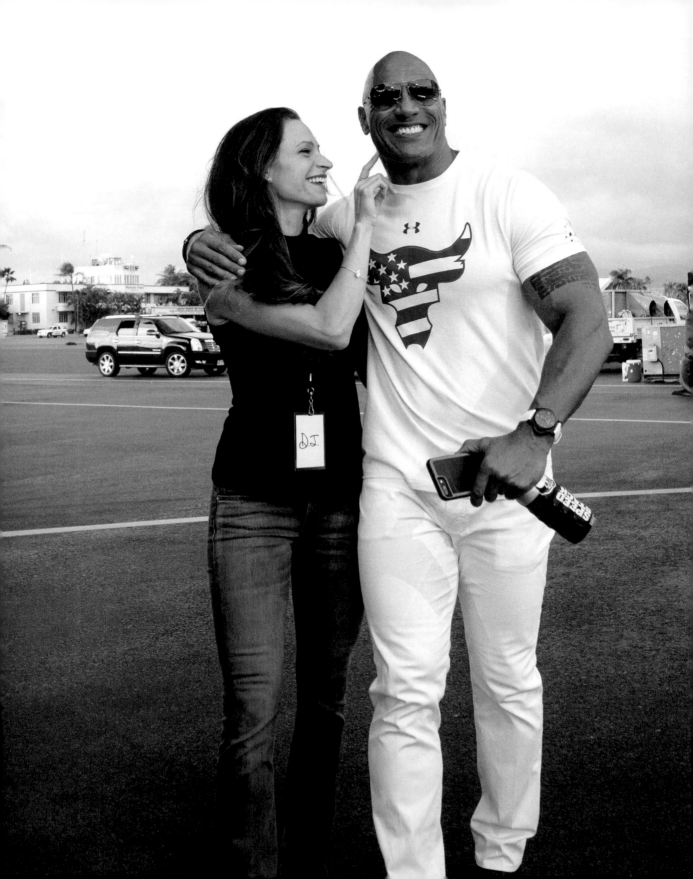

DJ and Lauren behind the scenes at
"Rock the Troops."

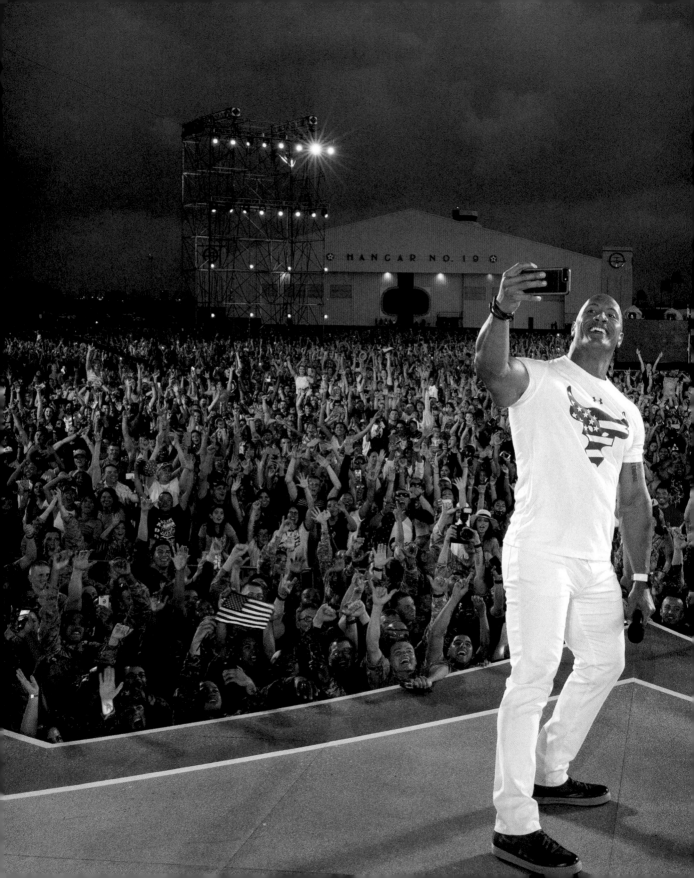

DJ tries to fit in as many of the 45,000 plus who attended "Rock the Troops" as he can into his selfie. At first we expected an audience of 25,000 but almost double that many fans turned out to hear bands like Flo Rida and Lynyrd Skynyrd and see performers like Kevin Hart and Jack Black.

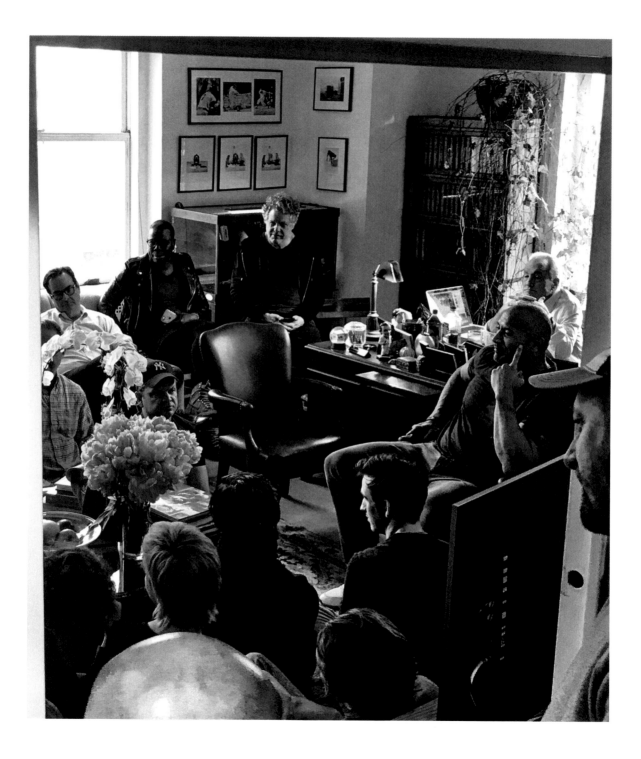

A rare peek of the *Saturday Night Live* process: DJ and producer Lorne Michaels listen to writers pitch ideas in the hope of having them selected for the show.

Any time he can pay tribute to Elvis, one of DJ's all-time favorite artists, he jumps on it. This time, DJ's dressed as The King for a promo, his fifth time hosting *Saturday Night Live*.

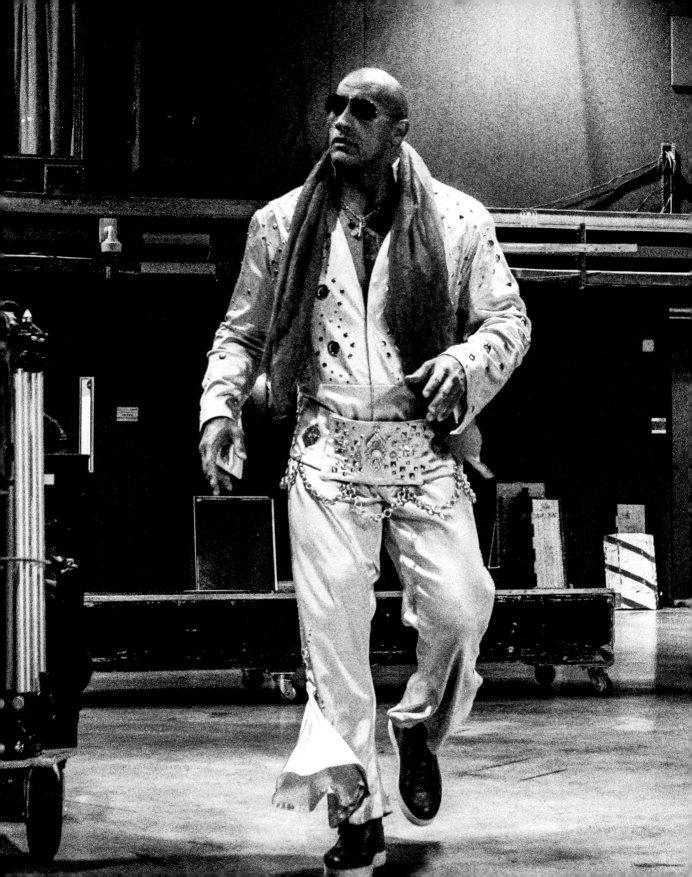

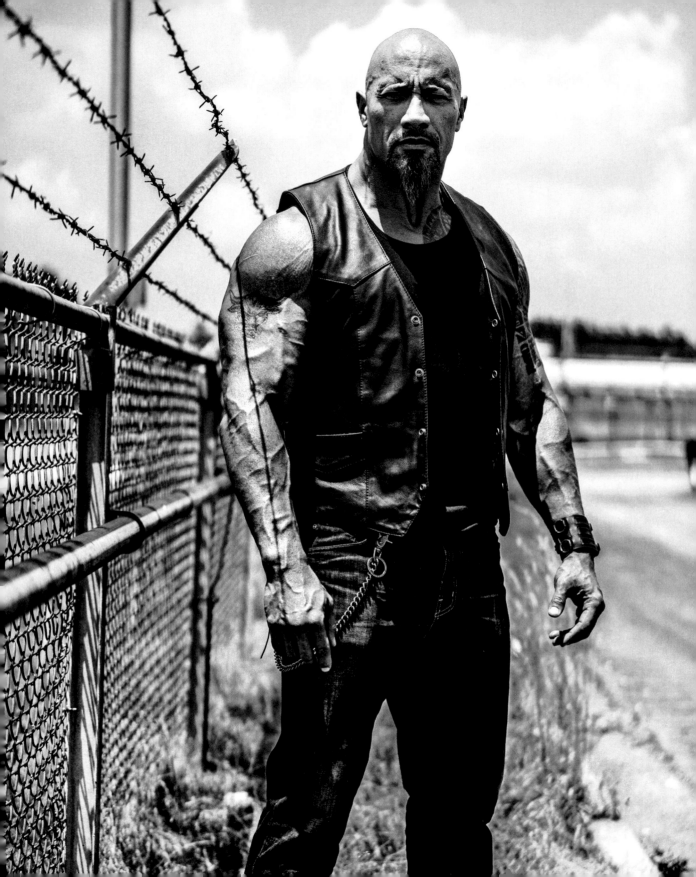

Our first look of Hobbs in *Fast 8* showed the character sporting an extra-long goatee we were fans of. But after this image was shared, the studio requested we shorten the beard. You don't always get what you want!

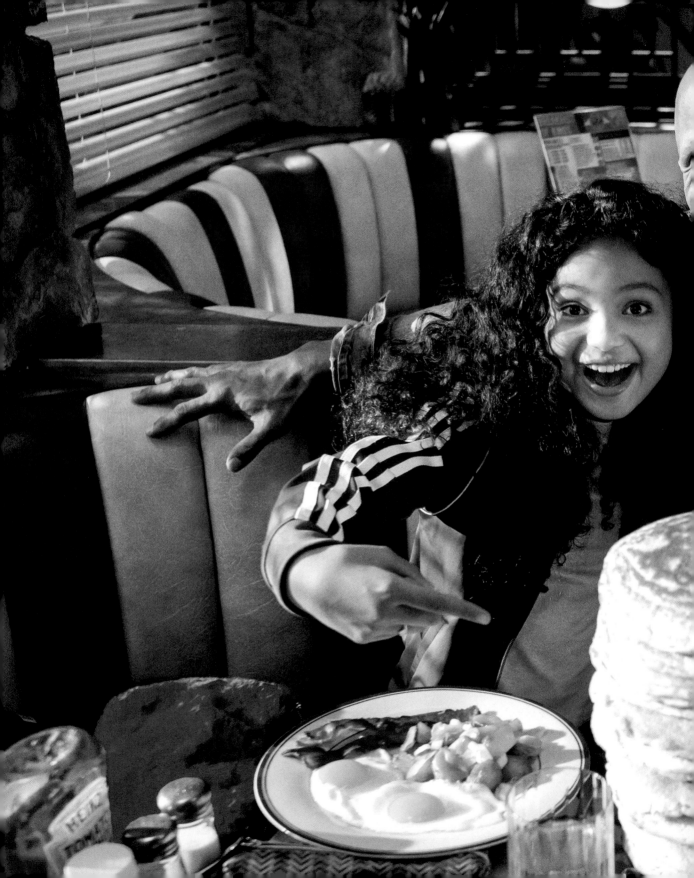

DJ with young actress Eliana Sua on the set of *Hobbs & Shaw*. Eliana's casting was a secret up to this point, so we wanted to take a fun picture for DJ to post and share with his over 250 million social media followers welcoming her to the *Fast & Furious* universe.

There's nothing quite like watching DJ perform live for thousands of screaming fans. He's often asked to memorize tons of last-second dialogue we finished writing right before going live, on top of being prepared to fight. Here he's practicing what he's about to say while hopping up and down to get his blood flowing for the performance.

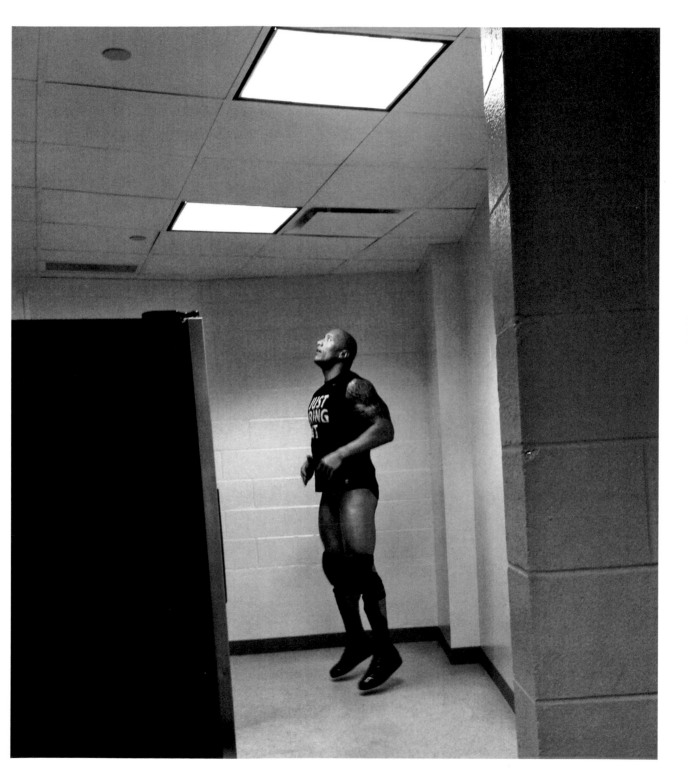

At the shoot for *People* magazine's
Sexiest Man of the Year.

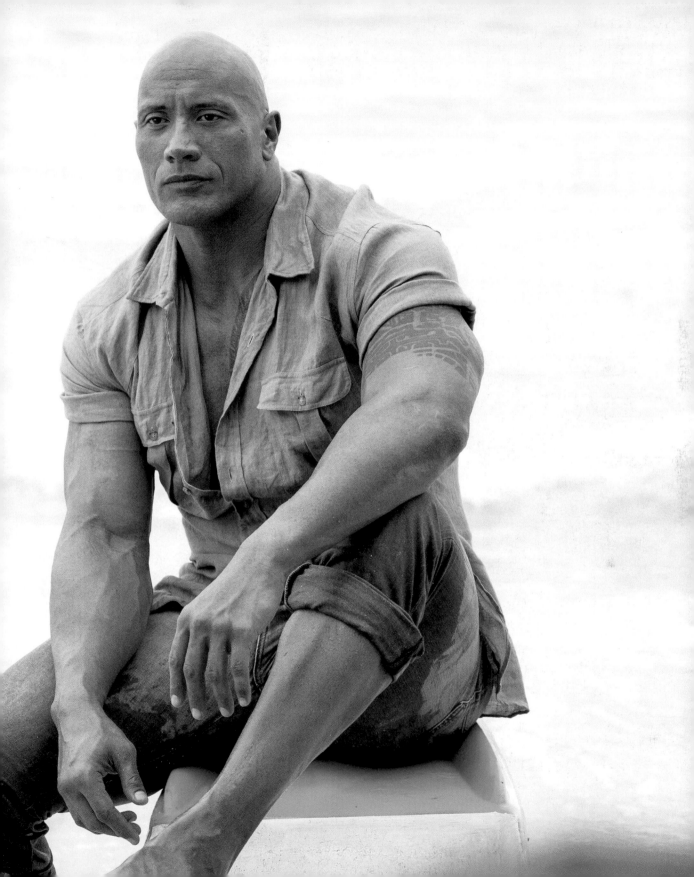

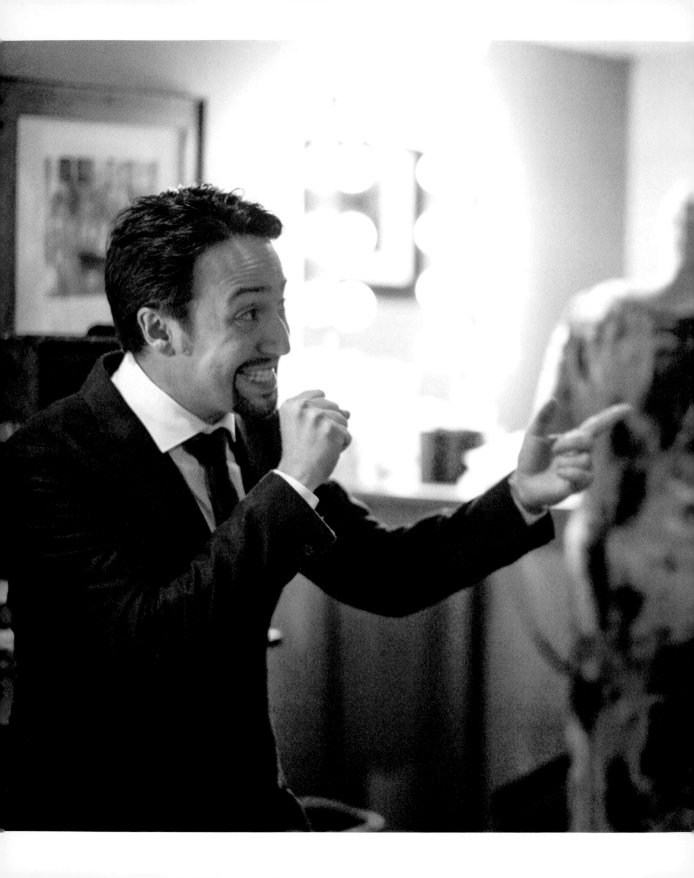

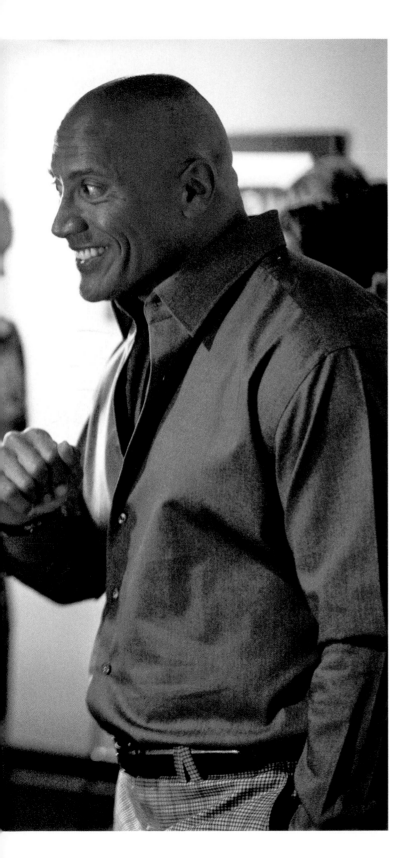

With Lin-Manuel Miranda practicing "You're Welcome," which Miranda wrote for *Moana*, before a live performance in front of an audience.

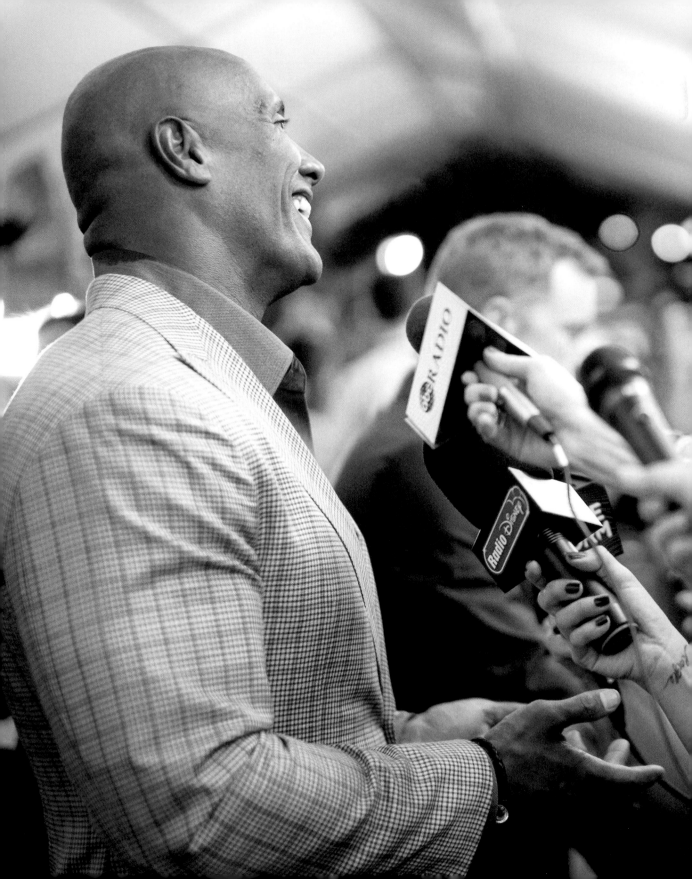

No matter who you are, DJ has the natural ability to make you feel special with his warmth and how present he is in every moment. I love how giddy with excitement the interviewer is here.

Celebrating after a long day of press with a glass of his Teremana tequila.

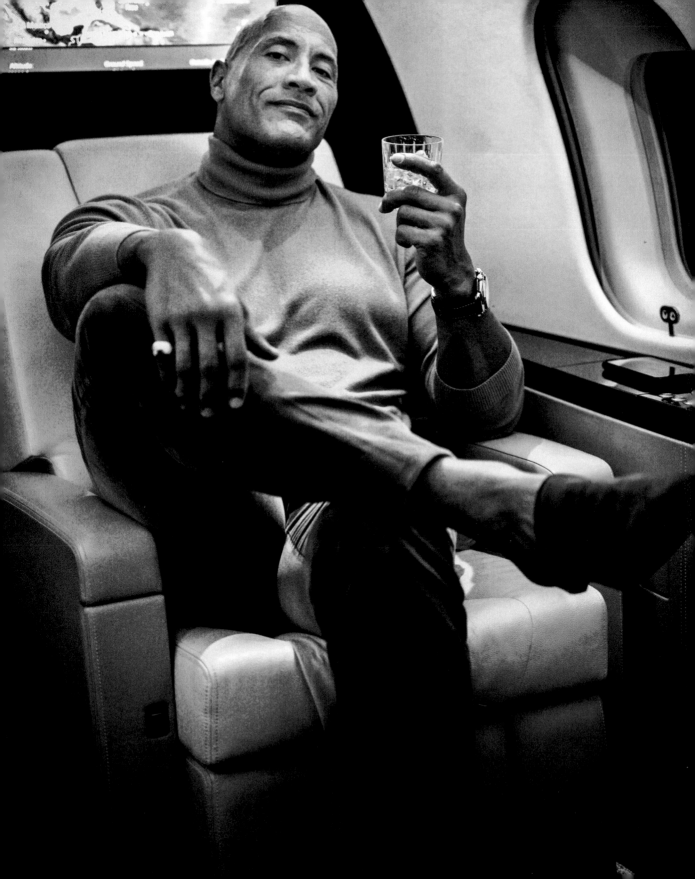

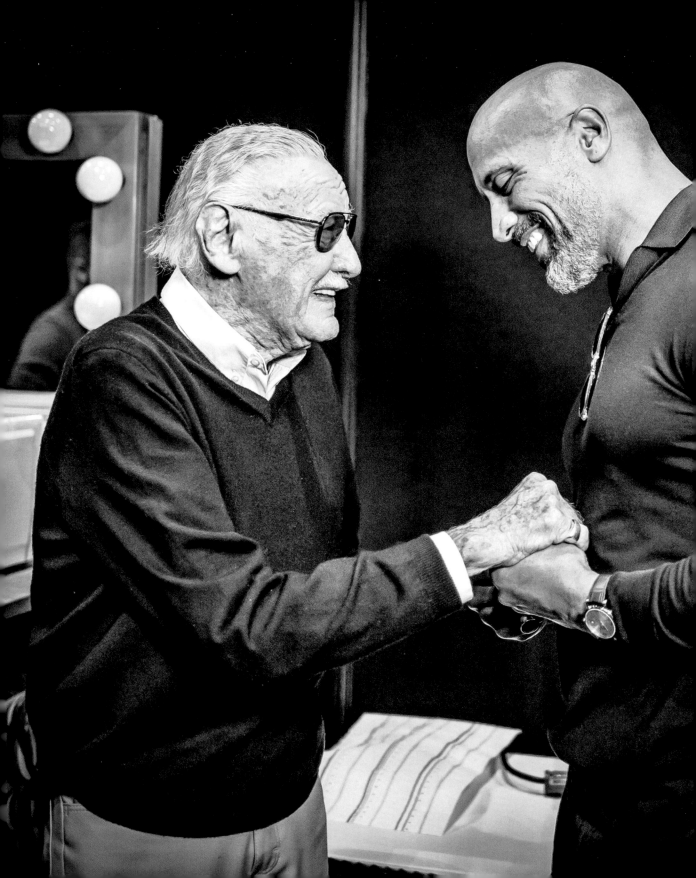

When DJ first broke into Hollywood, he met Stan Lee, who greeted him with open arms. Stan knew DJ had something special to give to the world and expected big things from him. Many years later, I was able to capture them reuniting as Stan heaped praise onto DJ for how proud he was of him and all his accomplishments. I love this image because you can see DJ humbled by Stan's warmth and kindness. Stan was one of the all-time greats and our world is a better place because of him and the creativity he inspired us to conjure. RIP Stan.

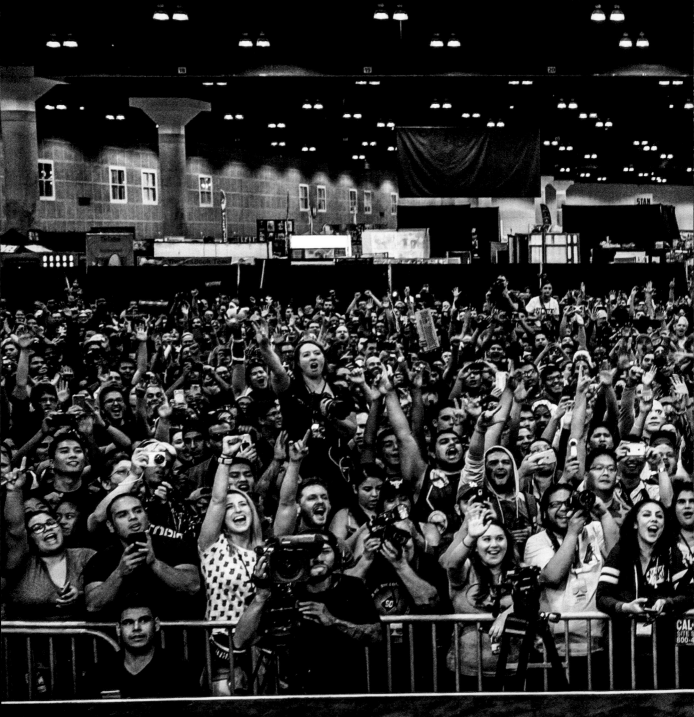

Creating a video for his social media with
some help from the Comic Con crowd!

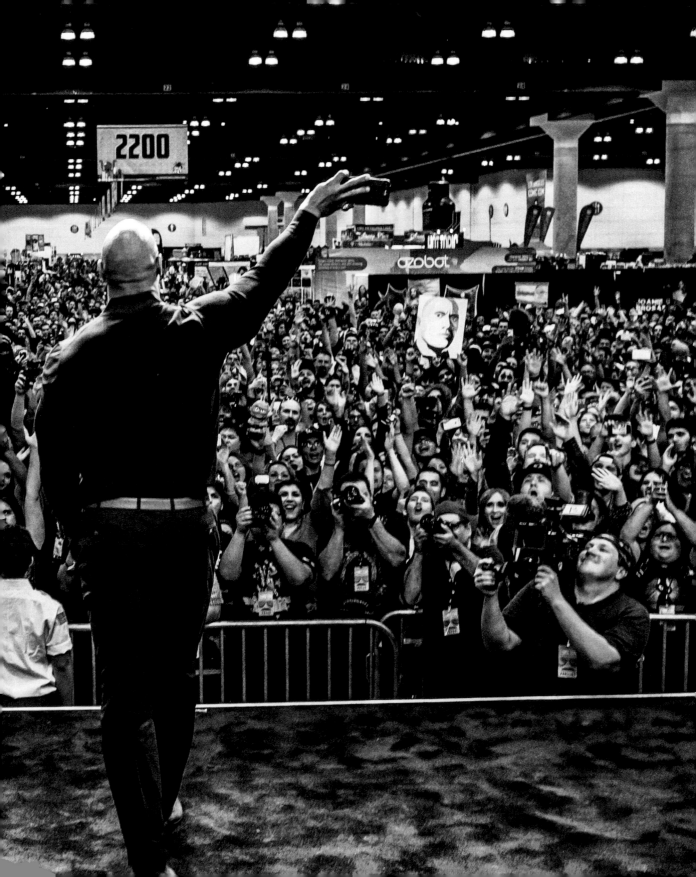

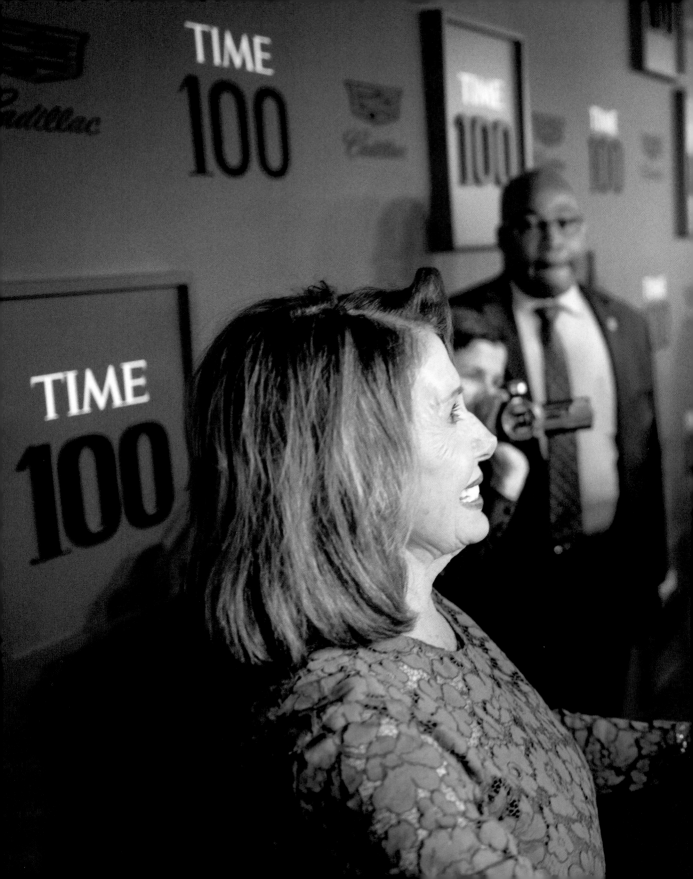

It was fun for DJ to be one of *Time* magazine's most influential people of 2019, along with artists, chefs, athletes, authors, activists, and political leaders like Speaker of the House Nancy Pelosi.

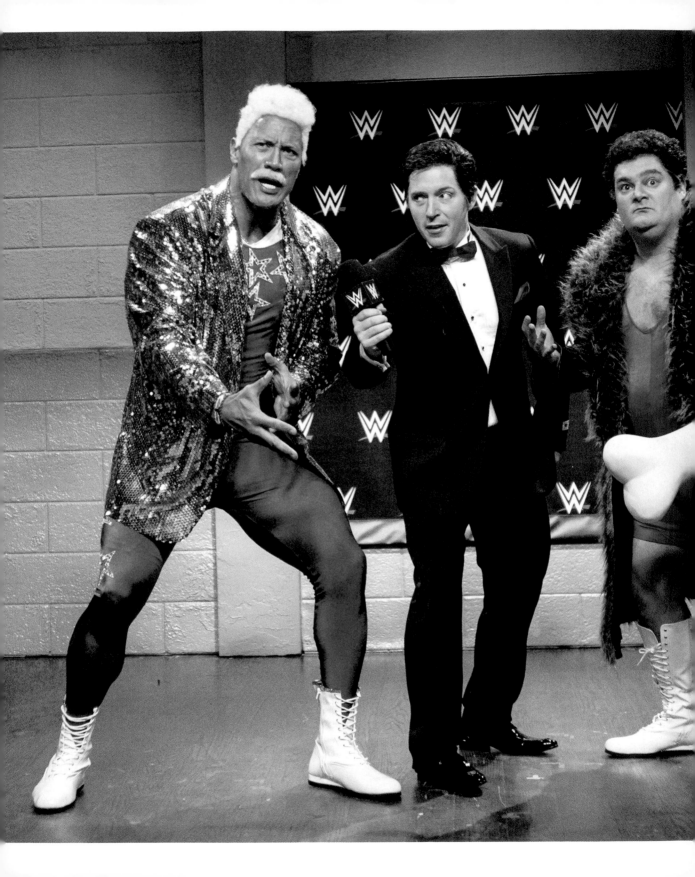

We thought this was the most memorable time DJ hosted *Saturday Night Live*. The show usually doesn't allow hosts to use their creative teams, but it made an exception for us. DJ, our former head WWE writer Brian Gewirtz and I came up with this bit.

Among the barrels of
Teremana tequila.

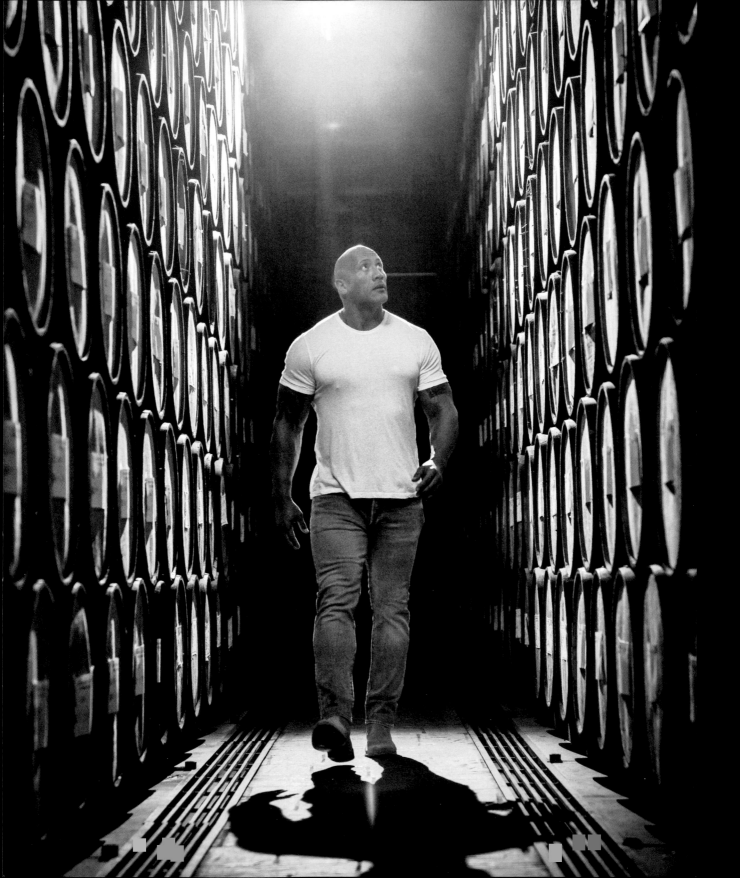

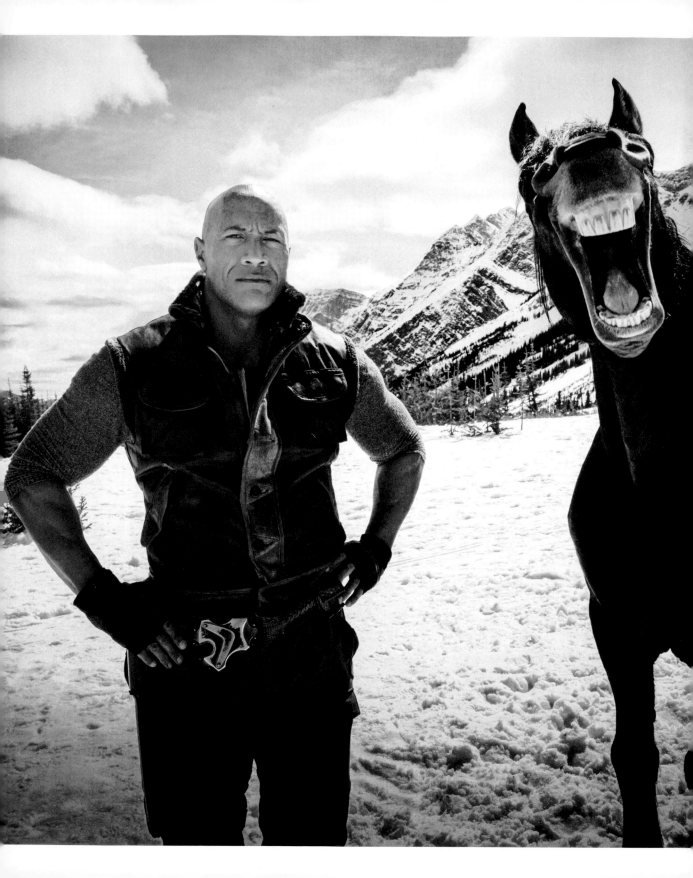

When we tried to take a majestic photo of DJ, this black Friesian horse had other ideas!

With Vince McMahon in a
private moment backstage.

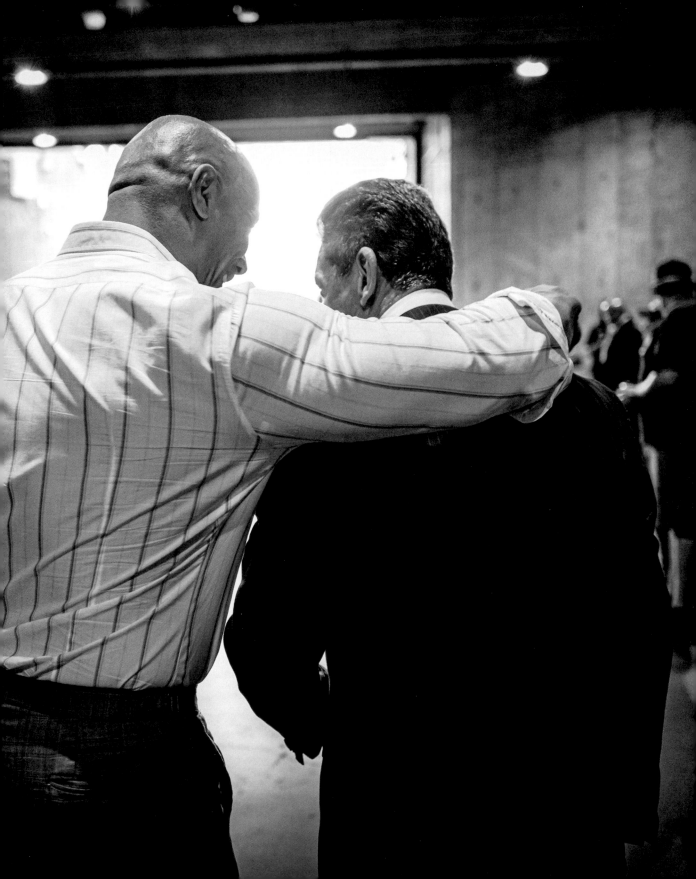

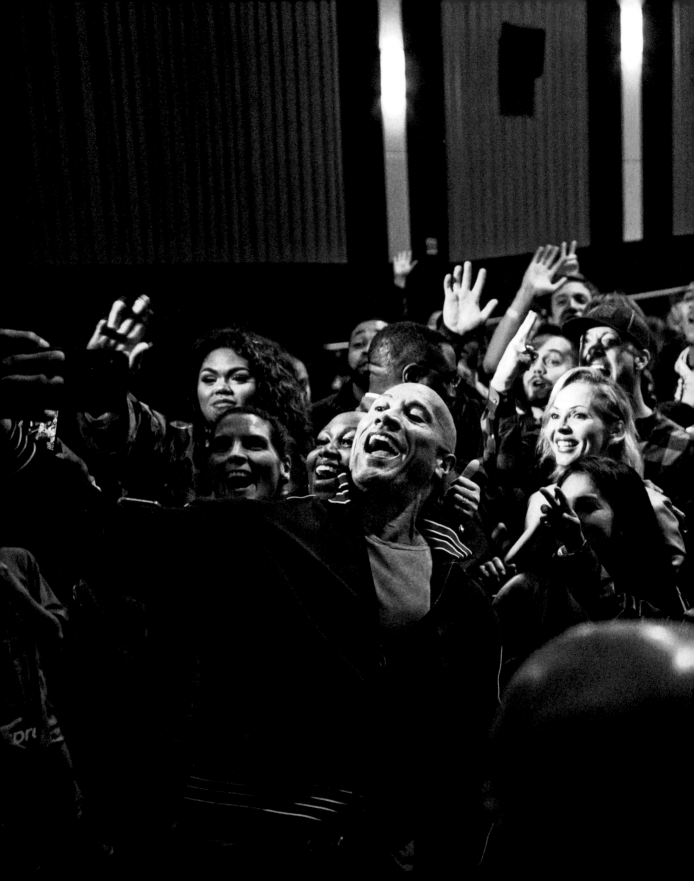

DJ loves being surprised and he also loves *being* the surprise: here he popped into an Atlanta audience watching *Fighting with My Family*.

DJ has always been a fan of pushing his body to the limit in the hopes of achieving new levels of greatness. It was this passion that helped him create *The Titan Games* for NBC. Here, he's surveying the insane obstacle course he crafted and where some of the world's greatest athletes would shortly compete.

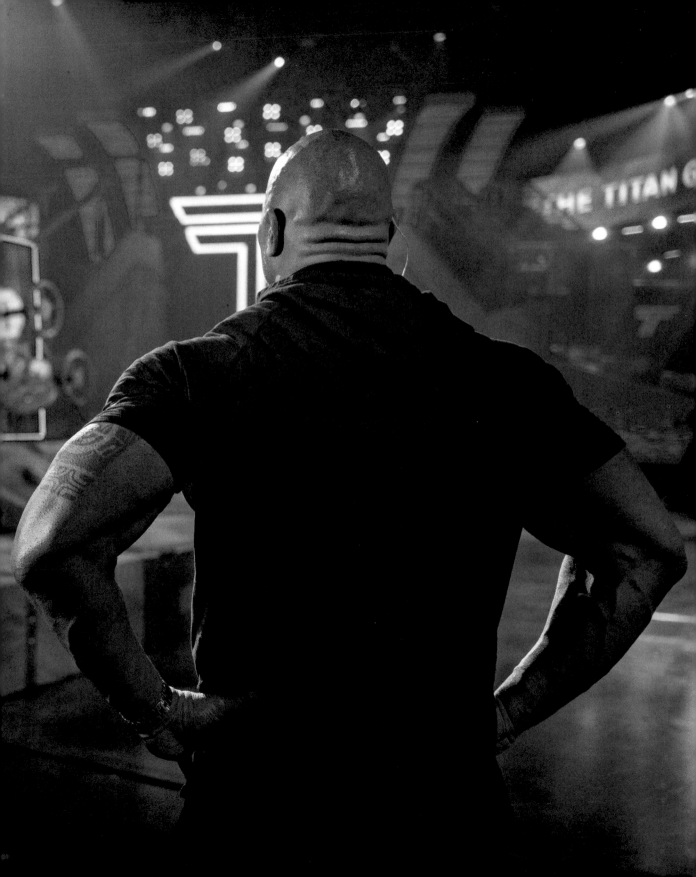

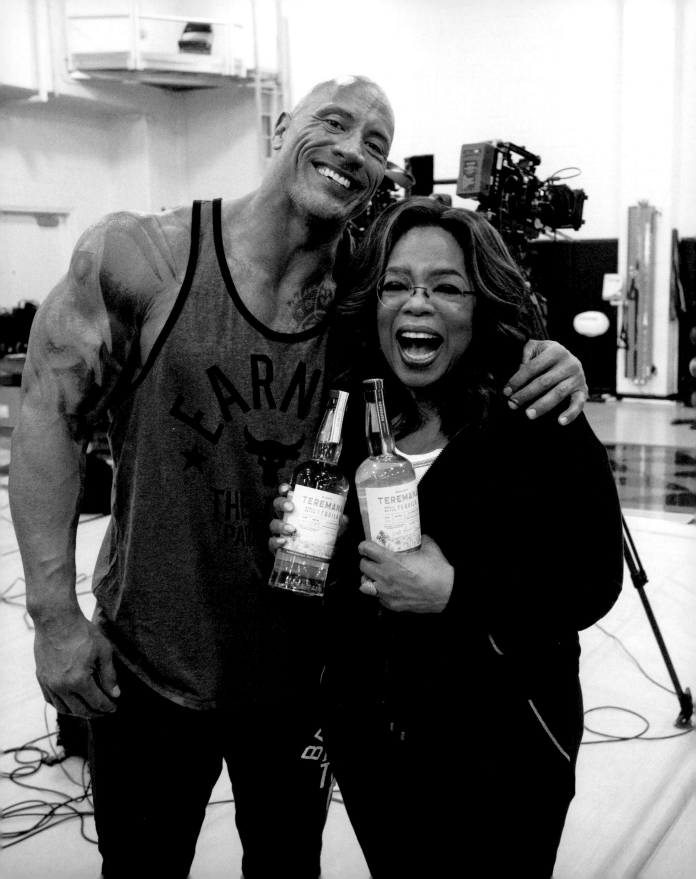

DJ and Oprah have always had a wonderful relationship. I don't think it's common knowledge, but Oprah is a massive tequila aficionado. So it was only fitting that DJ present Oprah with the first official bottles of his Teremana Tequila.

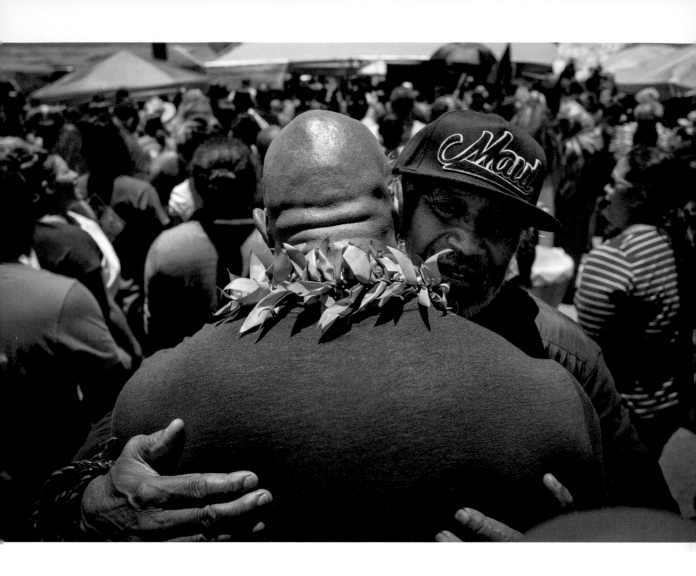

In fall 2019, peaceful protectors gathered to oppose
proposed construction of the giant Thirty Meter Telescope
on the sacred land of Hawaii's Mauna Kea volcano. You
can see both the protectors' gratitude and DJ's support
for their cause in this embrace.

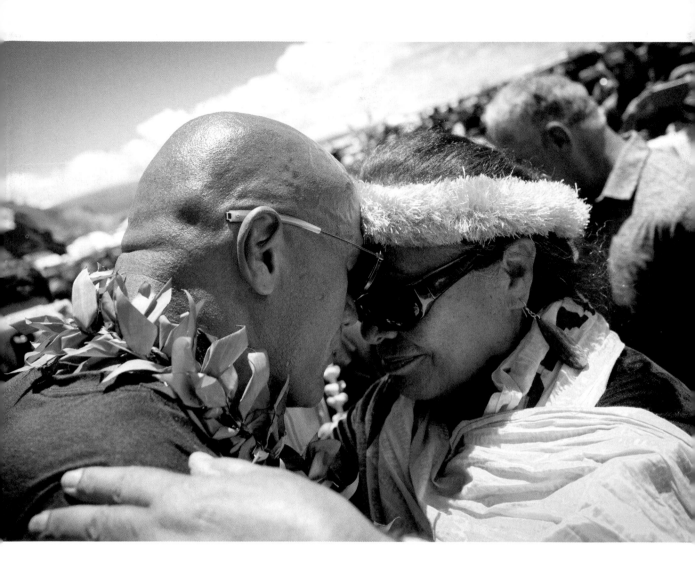

A Mauna Kea protector and DJ touching noses in a *hongi*,
the traditional Maori greeting.

DJ has accomplished many great things throughout his career, but receiving a star on the Hollywood Walk of Fame was very special. Here he takes a moment to thank the crowd while holding little Jasmine.

Acknowledgments

I'm so fortunate to be able to do what I do. None of it would be possible without love and support from my amazing friends, family, and coworkers. Thanks to my Leica family for being such fantastic partners and giving me the tools and the platform to grow as an artist. I'd especially like to thank all the amazing individuals who allow me to capture their images and tell stories through their beauty.

I'd also like to extend an extra-big thanks to the big, bald, brown, tattooed guy: DJ. Not only are you an amazing subject to photograph, but you're an incredible friend, fantastic role model, and an even better brother. Here's to the future and the many more images we will capture along the way.